THE BIG ACTIVITY BOOK FOR TEACHER PEOPLE

THE BIG ACTIVITY BOOK FOR TEACHER PEOPLE

JORDAN REID
AND
JACQUELINE ANN MAY

A TarcherPerigee Book

tarcherperigee

an imprint of Penguin Random House LLC
penguinrandomhouse.com

Copyright © 2022 by Jordan Reid

Based on the series by Jordan Reid and Erin Williams

Most TarcherPerigee books are available at special quantity discounts for bulk purchase for sales promotions, premiums, fund-raising, and educational needs. Special books or book excerpts also can be created to fit specific needs. For details, write: SpecialMarkets@penguinrandomhouse.com.

ISBN 9780593419403

Printed in the United States of America
1st Printing

Book design by Laura K. Corless

Dedicated to the 85 million educators worldwide
who taught our children with patience, passion,
and resilience during the dumpster fire of 2020.
May every one of you receive the adoration, recognition,
and full-on hero worship that you deserve.

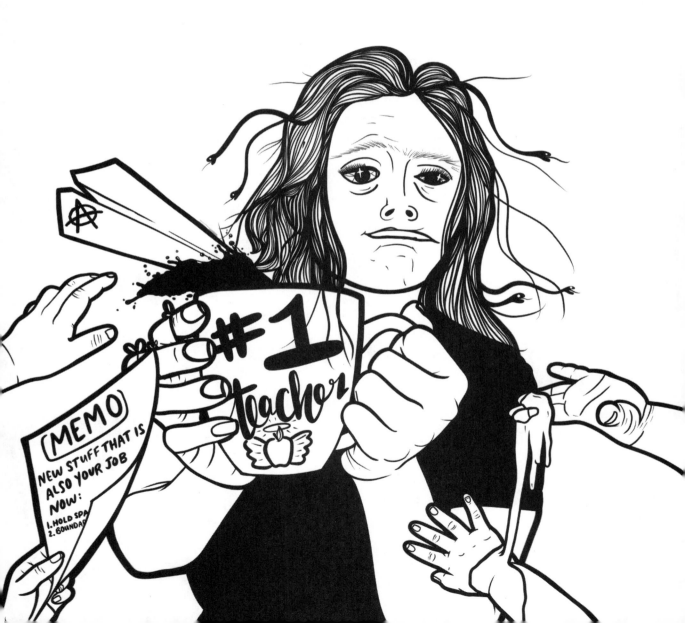

DEAR TEACHER PERSON,

First—and most important—did you notice that this book is not a mug, a succulent, or a Bed Bath & Beyond candle? That means that someone actually gave you something that is not a mug, a succulent, or a Bed Bath & Beyond candle. Amazing.

Now that we've celebrated that small win, let's celebrate *you*. Because you, as you already know, are a hero. You are a hero to the children you help navigate the minefields of adolescence. You are a hero to the colleagues you support and lift up every single day. You are a hero to the parents who, following the walk in the unicorn-and-sunshine-filled woods that was 2020, now hopefully realize that you are, to put it mildly, *essential*. Like, to the functioning of modern society.

You deserve a medal. And we got you one! See page 91.

Whether you're just starting out in your career (in which case, congratulations) or are nice and ancient and crusty (in which case, well done), this is the book for you. We've got pages and pages of activities to make you laugh even on days that include far too many bodily fluids that are not your own, helicopter parents who seriously need to stop emailing you Right. Now, and tragically infrequent bathroom breaks.

If you're having a rough day, flip to page 52 to identify the components of your ideal weekend (surprise! It involves silence). If you're having a *really* rough day, color in—and then cut out and destroy—the Fidget Spinner from Hell on page 33. Before your next parent-teacher conference, make sure to check out the alternatives to cuticle destruction

on page 49, and go ahead and print out multiple copies of the Back-to-School Night Drinking Game on page 47 (allll the espresso shots, please and thank you).

Now sit back, grab the writing implement of your choice—bonus points if it smells like chemical-tinged fruit—and enjoy. You deserve some time to relax. And also a major, major raise.

Love,
Jordan & Jackie

HOW TO USE THIS BOOK

1. Pick it up whenever the mood hits: In the morning instead of checking your work email (Spoiler: You have been given Additional Responsibilities); while hiding in the bathroom stall because that's the only place where people will *maybe* leave you alone; on a Sunday evening if you've already tried making watercolor paintings of Mr. Sketch markers (and other ideas for releasing your Inner Chill on pages 18–19).

2. Unlike, say, *War and Peace*, activity books are not known for their complex plot structure, so don't worry about consuming this in anything approximating an "order." Flip forward, flip back, pick a page at random and start there. Life as a Teacher Person can be more than a little stressful, what with all the rules and responsibilities, so consider this book the opposite of that and do with it whatever the heck you want — even if what you want is to regift it because you've got enough to do already, thanks, and you have no idea why Carol thought that this should be your Secret Santa present when all you wanted was a $5 Starbucks gift card, like everyone else got.

3. ⬤◁▐▐▐ Color me ▶▶ Wherever you see a little crayon like this one at the top of a page, that's a suggestion to go ahead and color it in. (But you don't have to color anything. Or you can color *everything*! See? Your book, your rules.)

4. If you're so inclined, take a picture of your various creations and tag us on Instagram at @ramshackleglam and @jackieannmaydraws — we want to see (and share!) your genius.

ALL ABOUT ME

Hello, my name is _____. I teach _____, which is _____.

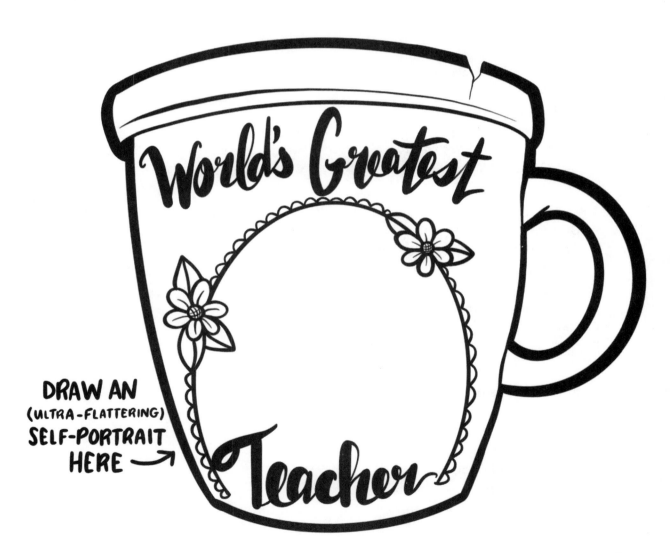

World's Greatest Teacher

DRAW AN (ULTRA-FLATTERING) SELF-PORTRAIT HERE →

GO ON, GO ON

My favorite thing about teaching is _____,
but I could very much do without _____.

Current sources of anxiety (*check all that apply*):
- ☐ Students
- ☐ Student loans
- ☐ Students' relationships with other students
- ☐ Parents
- ☐ Colleague dramz
- ☐ Administration dramz
- ☐ Dramz that have nothing to do with teaching because I HAVE A LIFE OUTSIDE OF SCHOOL, OKAY?

At the end of an average school day, I am usually covered with (*check all that apply*):
- ☐ Boogers
- ☐ Chewed-off bits of cuticle skin
- ☐ A light sheen of sweat
- ☐ My tears
- ☐ Other people's tears
- ☐ Glue-stick residue
- ☐ Lint

Over the years, I've mastered (*check all that apply*):
- ☐ Walking backward
- ☐ Functioning on ¼ the amount of sleep I used to get
- ☐ Seating charts
- ☐ Constant and ongoing caffeine consumption
- ☐ Bladder control
- ☐ Corralling children who are behaving like velociraptors
- ☐ Pinterest board curation

My favorite way to relax is (*check all that apply*):

- ☐ A long walk outside
- ☐ Naps and naps and naps
- ☐ A nice dinner with friends
- ☐ Actual (!) exercise (!)
- ☐ Sitting in an air-conditioned room with a cold Diet Coke and no company whatsoever
- ☐ A vat of wine
- ☐ Fortnite

In ten years, I will be (*check all that apply*):

- ☐ Doing exactly what I'm doing now, and loving it
- ☐ Doing exactly what I'm doing now, and hating it
- ☐ Doing something else (this: _____)
- ☐ Tenured
- ☐ Retired
- ☐ Living in a gated community where the only other residents are adorable kittens
- ☐ Hosting a podcast called *Class Isn't Over Yet*
- ☐ Sitting on a Tahitian beach with a much-deserved piña colada

COLOR ALL THE WEIRD ANXIETY DREAMS YOU'VE HAD

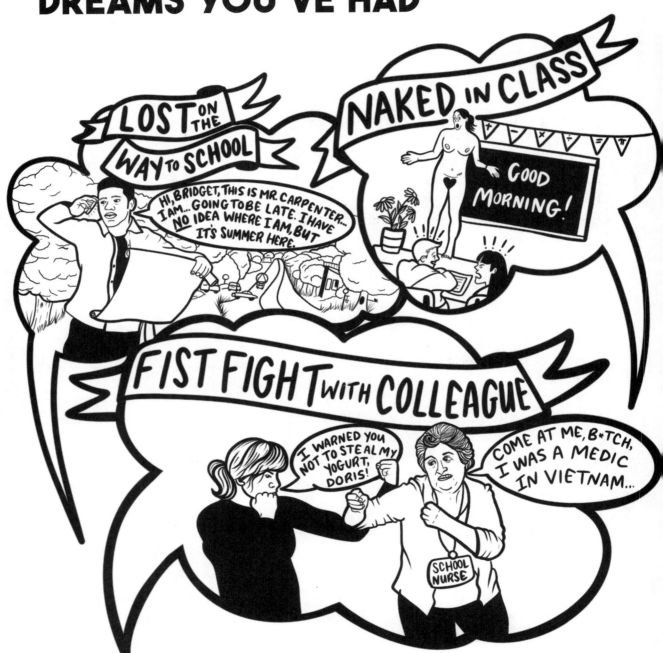

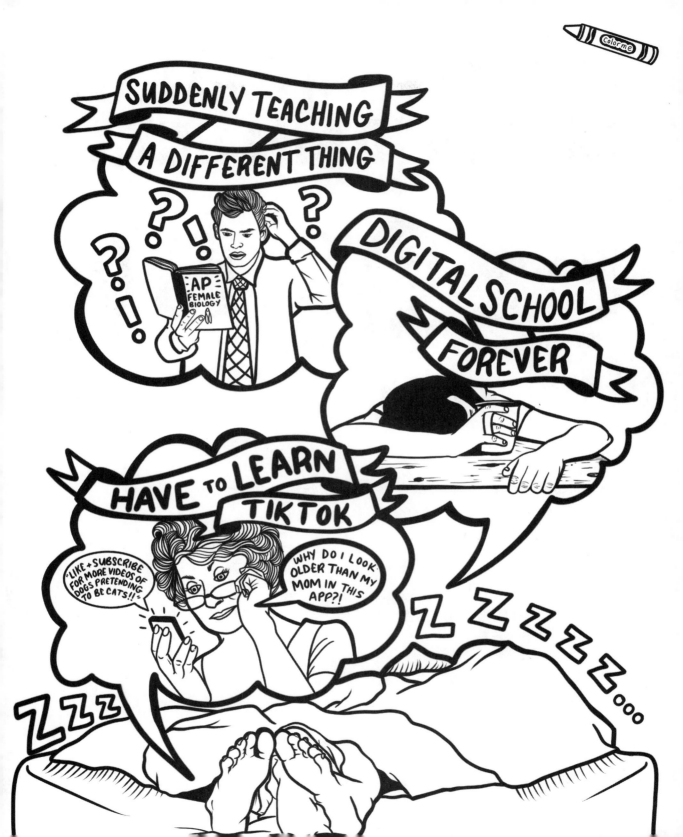

PUT THE SITUATION ON THE PAIN SCALE

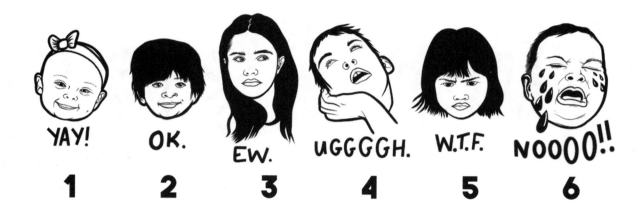

YAY!	OK.	EW.	UGGGGH.	W.T.F.	NOOOO!!
1	**2**	**3**	**4**	**5**	**6**

On a scale of YAY! to Noooo!!, how do you feel about each of the below?

_____ Printer out of magenta

_____ Flossing, the dance

_____ Backpacks on the floor

_____ Student just handed you actual trash

_____ Texting in class

_____ Drippy noses

_____ No coffee in the pot

_____ Arts & crafts

_____ Dabbing when sneezing

_____ Snapchat, generally

_____ TikTok, generally

_____ Parent wants to meet after class

_____ So many bathroom breaks

_____ Catching an obvious cheater

_____ Checking your school email

_____ The copier

_____ The laminator

_____ Vomiting child

_____ Oh god, lice

FINISH THE STORY:

Hand this page over to a partner, who will prompt you for each blank, then read your epic creation out loud.

It was a/an _____, _____ _____. I woke up at
 ADJECTIVE ADJECTIVE DAY OF THE WEEK
_____ and headed into the _____ for some _____. I grabbed
TIME OF DAY ROOM BEVERAGE
my _____, my _____, and some _____, and got into my
 NOUN NOUN FOOD
_____.
VEHICLE

When I walked through the doors, I went straight to my classroom and looked

around: I was all stocked up on _____, _____, and _____, so I
 PLURAL NOUN PLURAL NOUN PLURAL NOUN
was ready to start the day.

When my students arrived, I introduced myself and told them three facts about me:

I am _____ years old, my favorite thing to do is _____, and my favorite
 NUMBER VERB
song to sing along to in the car is _____. I showed them where to keep their
 TITLE OF SONG
_____, and assigned them each a _____. I also told them where they
PLURAL NOUN NOUN
go if they want some _____, and where they go if they need to _____. I
 BEVERAGE VERB
could tell they were a little _____, so I decided to read them a few pages of
 ADJECTIVE
_____.
TITLE OF BOOK

Next it was time to go over the class rules. "First," I said, "you're not allowed to

_____. Second, if you need to _____, let me know by _____.
VERB VERB VERB ENDING IN -ING
And finally, always make sure you _____ after you _____."
 VERB VERB

Before I knew it, the day was over—and it only took _____ hours! Well
 NUMBER
done, me. I definitely deserve some _____.
 BEVERAGE

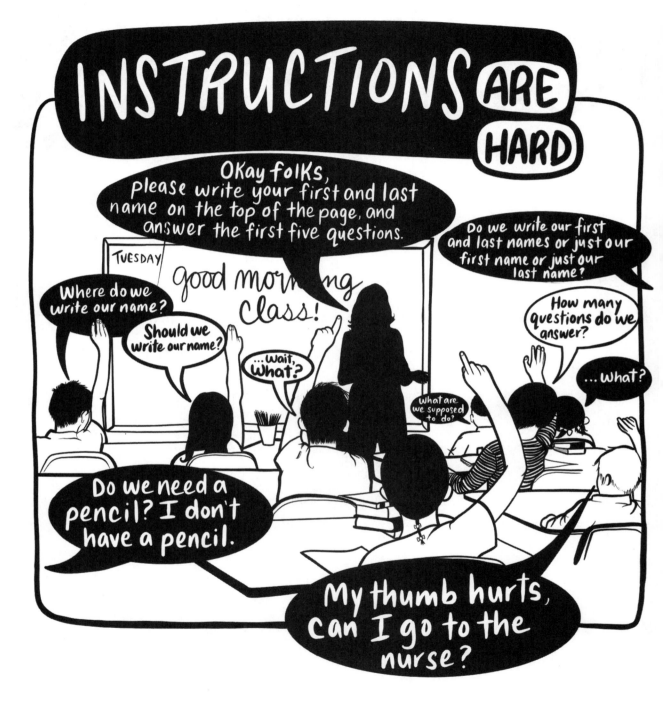

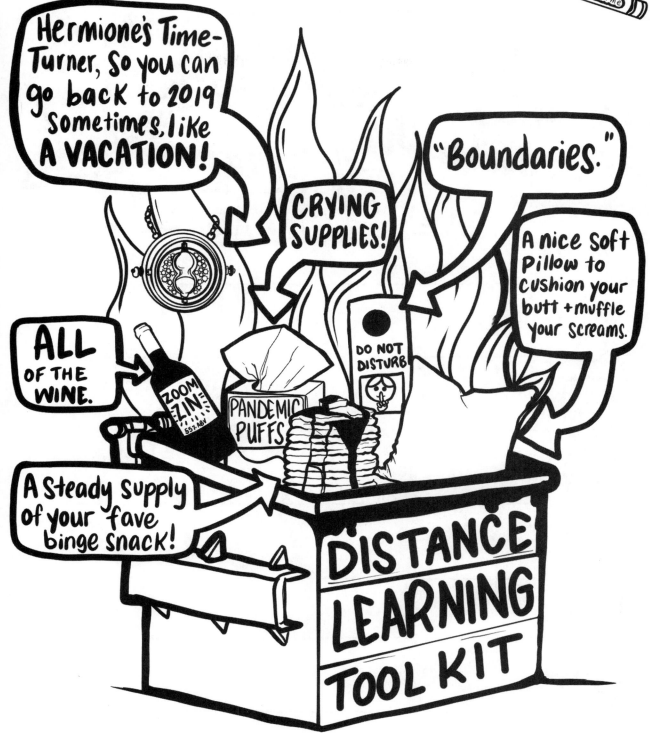

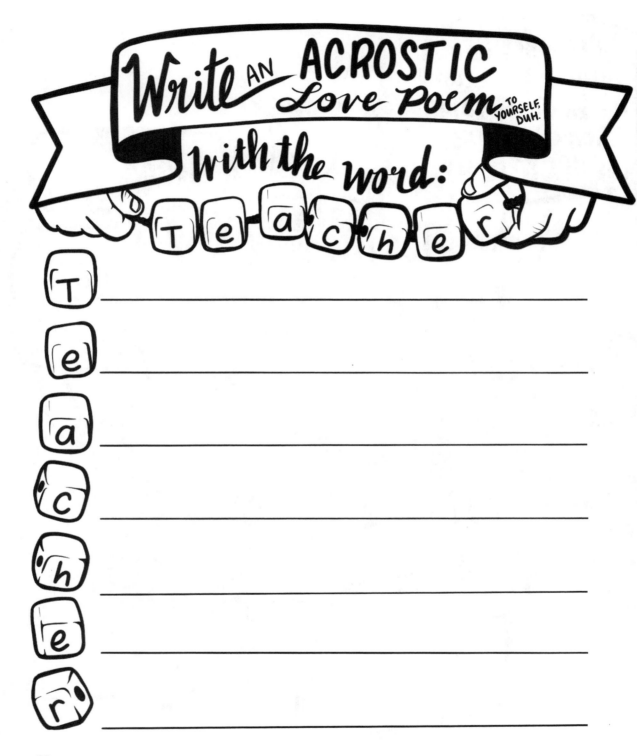

Write AN ACROSTIC Love Poem TO YOURSELF, DUH. with the word: Teacher

T _____

e _____

a _____

c _____

h _____

e _____

r _____

GET TO CHECKOUT AT TARGET WITHOUT SPENDING A MILLION DOLLARS

Avoid BeDazzled throw pillows!
Adorable multicolored Post-its!
Anything and everything made by Joanna Gaines!

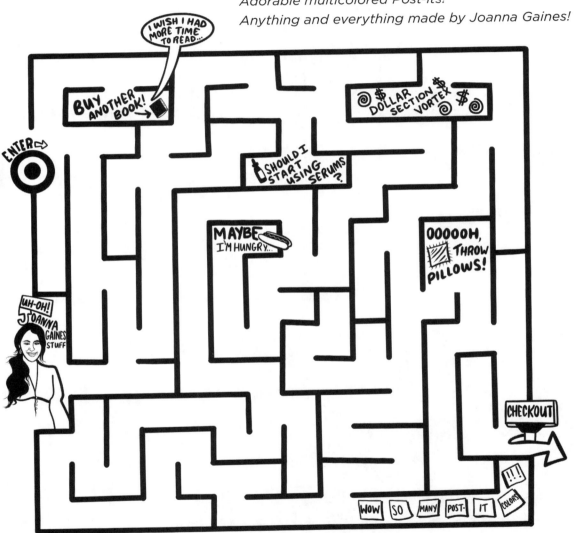

My last Dollar Spot purchase: _____

My last completely unintentional purchase that happened because I just couldn't help it:

WORD SEARCH 2020

```
D I S T A N C E L E A R N I N G O R F L
P R S Y N C H R O N O U S Y L B D B H R
N Z N F W U O O E E F R M X K R E H O E
W P K Q K V W T E X E N H X I P O Y T M
Y Z O M K A S Y N C H R O N O U S B S O
T U S P E A K I N G M O I S T L Y R P T
K N O I C J W S V B W N U J J D E I O E
L M G M M M A S K U P H Q Y A H N D T L
K U M G O O G L E C L A S S R O O M R E
W T H S O C I A L D I S T A N C I N G A
T E J Z Z W B L O C K D O W N Y S L G R
N Y A O D Q E B U B B L E C V W J P P N
E O X O T W Z F A M A S K N E J V O Z I
W U D M S N S G F O S I X F E E T D I N
N R K X F L Q U A R A N T I N E Q G D G
O S V I R T U A L L E A R N I N G O J X
R E V T S R W J T O I L E T P A P E R J
M L S C R E E N I S F R O Z E N B U S Y
A F U N P R E C E D E N T E D T I M E S
L G Y Q X C A I P T O U L P N C E R T Y
```

FIND ALL THE WORDS YOU NEVER, EVER WANT TO HEAR AGAIN.

QUARANTINE

UNMUTE YOURSELF

MASK UP

MASKNE

DISTANCE LEARNING SCREEN IS FROZEN UNPRECEDENTED TIMES

NEW NORMAL

TOILET PAPER

VIRTUAL LEARNING HOTSPOT

HYBRID POD SIX FEET LOCKDOWN

ZOOM BUBBLE

GOOGLE CLASSROOM SOCIAL DISTANCING SPEAKING MOISTLY

SYNCHRONOUS ASYNCHRONOUS REMOTE LEARNING

As a bonus, cut it out and tape it on your wall. Ta-da: All of the color and beauty, none of the probably-will-die.

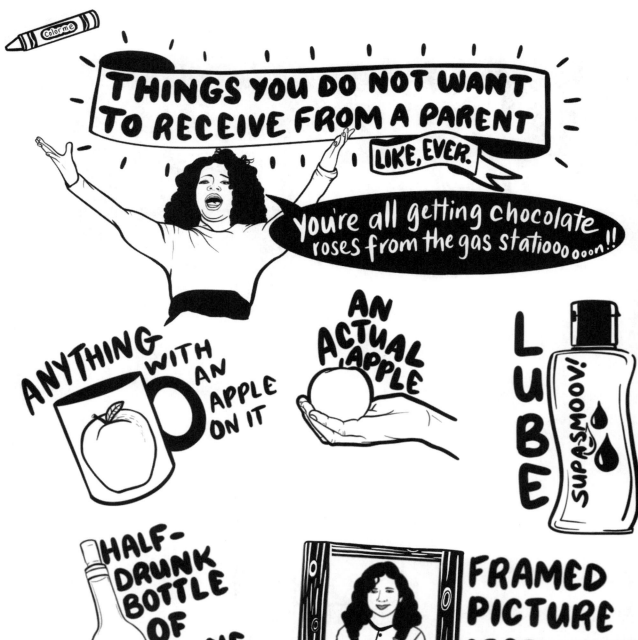

THINGS YOU DO NOT WANT TO RECEIVE FROM A PARENT

LIKE, EVER.

You're all getting chocolate roses from the gas statioooooon!!

ANYTHING WITH AN APPLE ON IT

AN ACTUAL APPLE

LUBE SUPASMOOV!

HALF-DRUNK BOTTLE OF WINE

Big Girl Jui

FRAMED PICTURE OF STUDENT

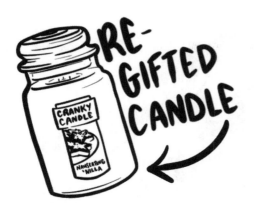

RE-GIFTED CANDLE

CRANKY CANDLE

Nauseating 'Nilla

MY FAVORITE GIFT EVER WAS:

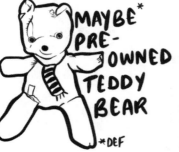

MAYBE* PRE-OWNED TEDDY BEAR

*DEF

MORE

More LOTION P.U.

???

AND OH GOD, THIS ONE WAS THE WORST:

Hey BOSS BABE!

INVITATION TO A PARENT'S "NAUGHTY" TOY PYRAMID SCHEME "PARTY"

VERY OLD PASTA

FOOD THAT WAS CLEARLY PURCHASED FROM HOMEGOODS

You spend 99 percent of your day worried about the care and well-being of others. Consider this your reminder that it's okay to take some time to care for yourself.

Today is __/__/__.

On a scale of 1 to 10, my anxiety level is _____.

I'd feel better if I were (check all that apply):
- ☐ Watching anything with a Kardashian in it
- ☐ Exercising
- ☐ On my sixth cup of coffee
- ☐ Listening to Enya
- ☐ Hanging out with this person: _____
- ☐ Alone literally anywhere
- ☐ Asleep

I'd feel worse if I were *(check all that apply)*:

- ☐ Watching anything with a Kardashian in it
- ☐ Exercising
- ☐ On my sixth cup of coffee
- ☐ Listening to Enya
- ☐ Filing my taxes
- ☐ Cleaning this thing that NOBODY BUT ME EVER CLEANS: _____
- ☐ On a field trip

The thing I'm most worried about is _____, but this probably won't happen because _____. But even if it *did* happen, everything would eventually be okay, because _____. Whew.

Here are five things I'm looking forward to:

1. _____
2. _____
3. _____
4. _____
5. _____

I have twenty bazillion things on my plate, but fiiiiiine, I will do one or more of the following today:

- ☐ Make a cup of tea and enjoy it slowly, without any distractions.
- ☐ Meditate for ten minutes, because it helps.
- ☐ Pick up the phone and call (not text) someone who makes me happy.
- ☐ Eat a meal while sitting down that's delicious *and* good for me, because I deserve it.
- ☐ Do one of those self-care "spa nights" that everyone says makes you feel better and actually kinda does.

HOW TO:
UNLEASH YOUR INNER CHILL

Are you a hippie? That's cool. You can skip this page, because you already know about mantras, and probably even use them. If not, you might need a few techniques for achieving a state of Complete Chill after a particularly rough day.

1. Designate a space in your home that is just for you, even if it's just a corner in your bedroom. Create an altar by hanging Ms. Frizzle fan art and a papier-mâché lantern made of confiscated Pokémon cards. Light a few dozen Apple-Cinnamon Yankee Candles that you were given for Teacher Appreciation Week. Luxuriate in the aroma of baked goods washed in Listerine.

2. Play Gregorian chants or that ambient electronica that yoga teachers seem to like. Close your eyes. Picture yourself holding a Target gift card for ten thousand dollars.

3. Recite affirmations such as "I am a capable, compelling instructor who differentiates like a ninja" or "*Everybody* cries in bathrooms on Mondays."

4. Make a watercolor painting of a box of Mr. Sketch markers with not a Single. Color. Missing. Inhale deeply. Ooh, they're the scented kind. Oh no, you're holding Licorice. Stop breathing immediately.

5. Get one of those stones that says "Relax" on it and hold it awhile.

QUIZ:
WHICH POP CULTURE TEACHER ARE YOU?

Take the (completely scientific) quiz below to find out which movie you 1000 percent should have starred in.

You caught your student passing a note. Your move:
 a) Tell them not to get caught next time. Hey, you were a kid once, too.
 b) That's what detention is for. Do not pass go, do not collect a good grade.
 c) Gently reprimand them. Do they need a hug? They need a hug.
 d) Ignore it completely, because, what, like you're their parent?

In the top drawer of your desk, you always keep:
 a) Candy! Everybody likes candy. Mostly you.
 b) A truly impressive collection of stuff you've confiscated over the years. Give it back at the end of the day? Over your dead body.
 c) Essential oils to cure all life's ills.
 d) Your phone—that Tinder profile won't check itself.

On an average workday, you're wearing:
 a) Sweats (at least until someone tells you not to, in which case you'll break out your Formal Sweats—ahem, #athleisurewear).
 b) A pressed suit that you laid out the night before, because those kids are going to RESPECT YOU, DAMN IT.
 c) Happy, bright colors. You're fun! You're comforting! You're a paragon of positivity in a cloak of ethereal chiffon.
 d) Whatever you wore last night.

Two of your students are fighting and it's disruptive. What do you do?

a) Break out the electric guitars and jam. Music soothes the savage beast, et cetera.

b) Lock them in a closet together until they sort it out. That's illegal? It shouldn't be.

c) Sounds like there are two somebodies in the room who need to sit down and talk about Feelings.

d) Leave.

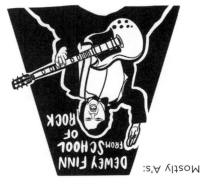

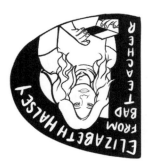

What's in your coffee cup right now?

a) 10,000 shots of espresso.

b) Coffee. Black. Obviously.

c) Organic green tea.

d) Tequila with a tiiiiiny sprinkling of Valium.

Mostly D's: ELIZABETH HALSEY FROM BAD TEACHER

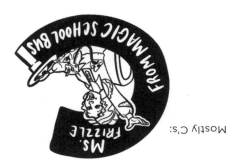

Mostly C's: MS. FRIZZLE FROM MAGIC SCHOOL BUS

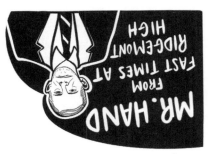

Mostly B's: MR. HAND FROM FAST TIMES AT RIDGEMONT HIGH

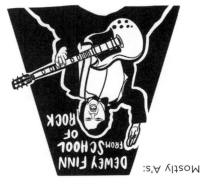

Mostly A's: DEWEY FINN FROM SCHOOL OF ROCK

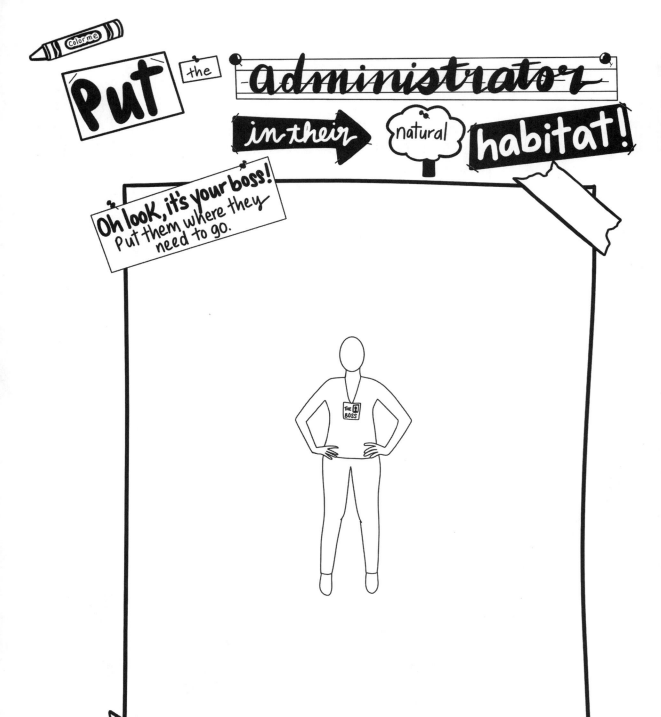

Put the administrator in their ➜ natural habitat!

Oh look, it's your boss! Put them where they need to go.

HOW TO:
HANDLE (ACCIDENTAL) PARTIAL NUDITY

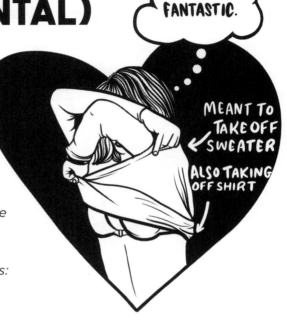

Have you ever been mid-lesson when you've looked down, only to discover that one or more Very Important Buttons is absent, thereby revealing your least-cute undergarments to a roomful of small human beings, all of whom are in possession of a tiny recording device capable of feeding directly to Facebook Live?

Some ideas for what to do next time this happens:

DANCE IMPROV
You're twirling! You're swirling! You're a glorious blur of motion! (Fix that button while you swirl, yeah?) When you're done with your impromptu performance, your students will be thoroughly confused by everything they just saw.

STOP, DROP, AND ROLL
OMG, what's that under the desk?! You need to get that . . . thing. *Right. Now.*

DISTRACTION BY NEAR-DEATH EXPERIENCE
Scream in agony and fall to the ground. Be unconscious. Bleed a little, if that's something you can do on command. Should an ambulance arrive, get better. It's a miracle!

DEAL WITH IT
Know most of your students aren't paying attention anyway and get on with your day.

ESSENTIAL OILS: CLASSROOM EDITION

Essential oils are lovely—like tiny massages for your nasal cavities. Just throw a few drops of citrus oil into your desktop diffuser and watch as your students magically apply themselves to their organic chemistry assignments whilst you experience the multisensory joy of running through a field of orange trees as the sun lifts over the horizon.

Unfortunately, your classroom aromas are more likely to be akin to the below.

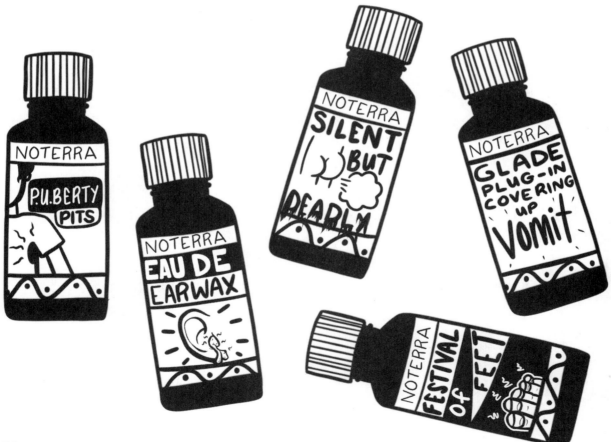

THINGS YOU NEVER THOUGHT YOU'D SAY OUT LOUD

And with a dead-straight face, at that.

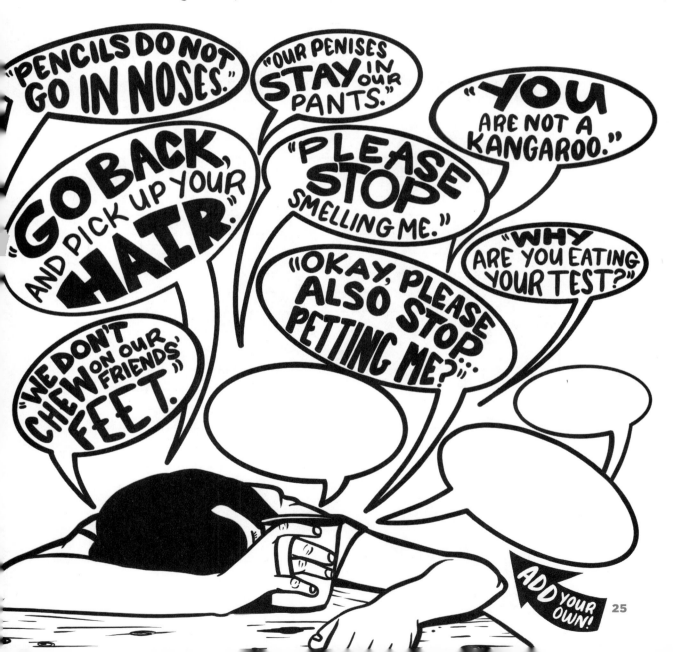

WORD ASSOCIATION TIME!

What's the first word that comes to mind when you read each of the below?

Common Core: _____

Parent-teacher conference: _____

Bandwidth: _____

First bell: _____

Last bell: _____

Spring break: _____

Holiday crafting: _____

Halloween: _____

Goodie bags: _____

Cafeteria lunch: _____

Pop quiz: _____

Happy hour: _____

PTA: _____

AFT: _____

IEP: _____

Standardized tests: _____

Weekends: _____

Clorox wipes: _____

Teacher Appreciation Week: _____

Apples: _____

Target gift cards: _____

Summer vacation: _____

Pizza bagels: _____

Distance learning: _____

Betsy DeVos: _____

Journal:

Doing this exercise made me feel _____.

Clearly, I am in need of a little more _____.

UNSCRAMBLE THE CELEBRITY TEACHERS

There are plenty of famous faces out there that got their start commanding a different kind of stage, with a much less attentive audience. Apparently, being a teacher makes you uniquely well-positioned for a future of mass adulation from crowds cheering your name. Who knew?!

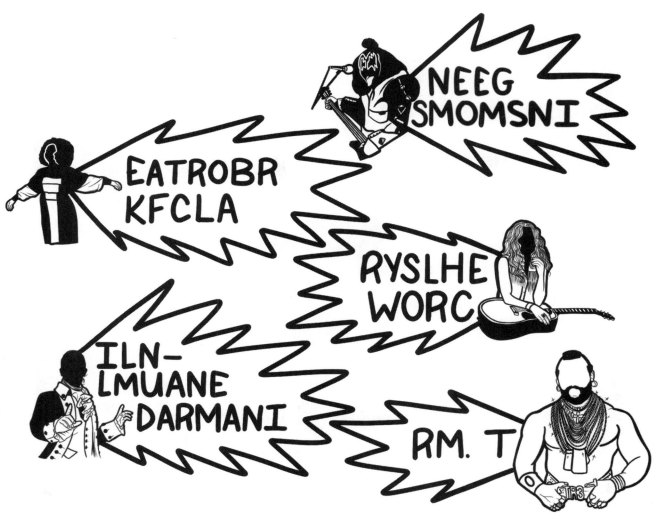

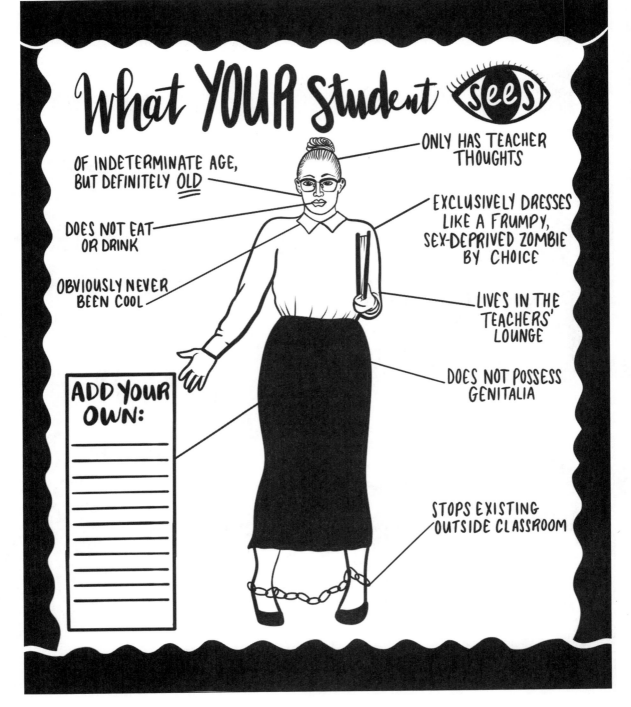

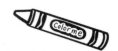

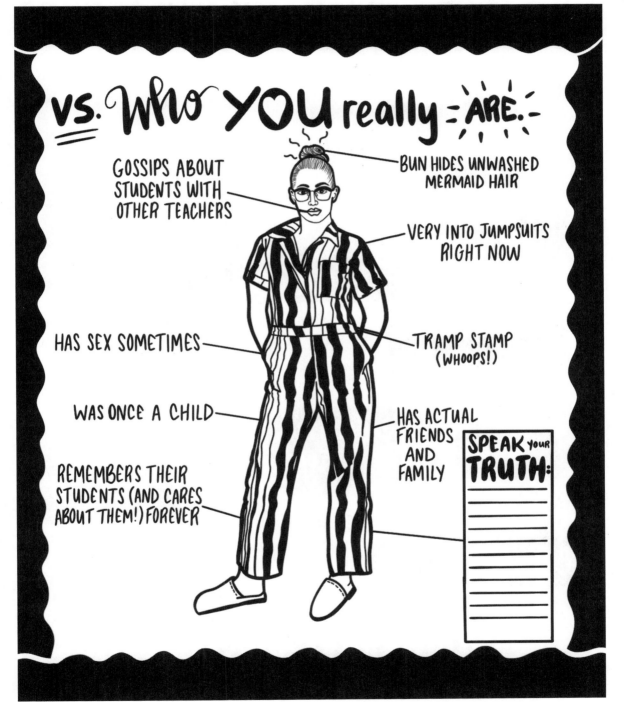

MATCH THE WORD ONLY TEACHERS KNOW TO ITS DEFINITION

1. EWMUNITY

2. SUGARGEDDON

3. GLITTINCIDENT

4. LIP-ZIPIUS

5. AVOIDIFACATUS RAPIDOSUM

6. CONFERANT

7. IMPROVIPLAN

A — WHAT YOU DO WHEN A PARENT WANTS TO SPEND THE WHOLE CONFERENCE TALKING ABOUT HOW SPECTACULAR THEIR EXTREMELY AVERAGE CHILD IS.

B — WHEN YOUR PARENT-TEACHER CONFERENCE TURNS INTO A 30-MINUTE EXPLOSION OF RAGE + JUDGMENT.

F — THE KIND OF WOLVERINE-LEVEL IMMUNE SYSTEM EARNED BY YEARS OF HAVING YOUR MOUTH SNEEZED INTO BY A ROOM FULL OF INTENSELY GERMY SMALL HUMANS.

C — WHEN YOU CAN'T FIND YOUR LESSON PLAN AND JUST WING THE HELL OUT OF IT.

D — THE THING THAT HAPPENS EVERY. SINGLE. TIME. YOU DECIDE IT'D BE A GOOD IDEA TO INCORPORATE GLITTER INTO A CRAFT PROJECT.

GREAT IDEA! GLITTER.

F.M.L.

E — WHAT HAPPENS AT EVERY HOLIDAY PARTY WHERE EXCESSIVE AMOUNTS OF SUGAR ARE CONSUMED.

REVOLUTION!

G — WHEN A STUDENT SUDDENLY DEVELOPS SEVERE SYMPTOMS OF ILLNESS ON THE MORNING OF A BIG TEST.

Answers: 1F, 2E, 3D, 4A, 5G, 6B, 7C

GET THROUGH THE SCHOOL DAY WITHOUT SCREAMING

Avoid parents who "just want to chat real quick!" Irreparably broken printers! Middle school-ers who don't know that deodorant exists!

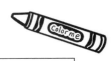

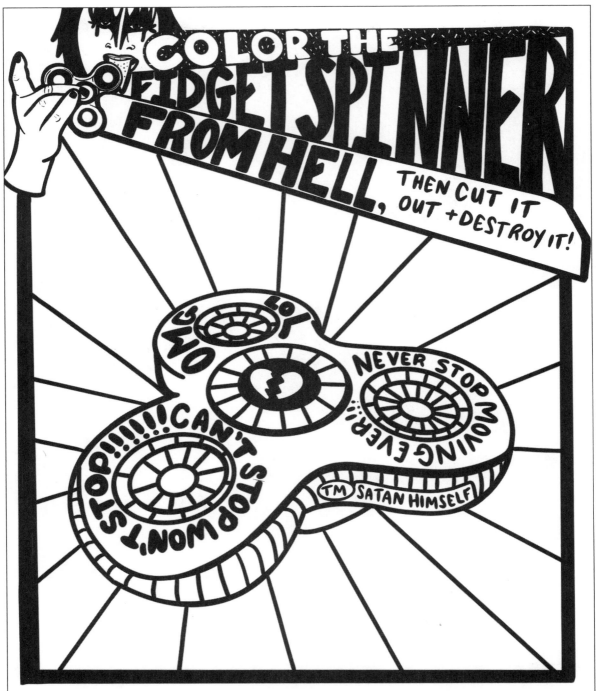

PAGE INTENTIONALLY LEFT BLANK

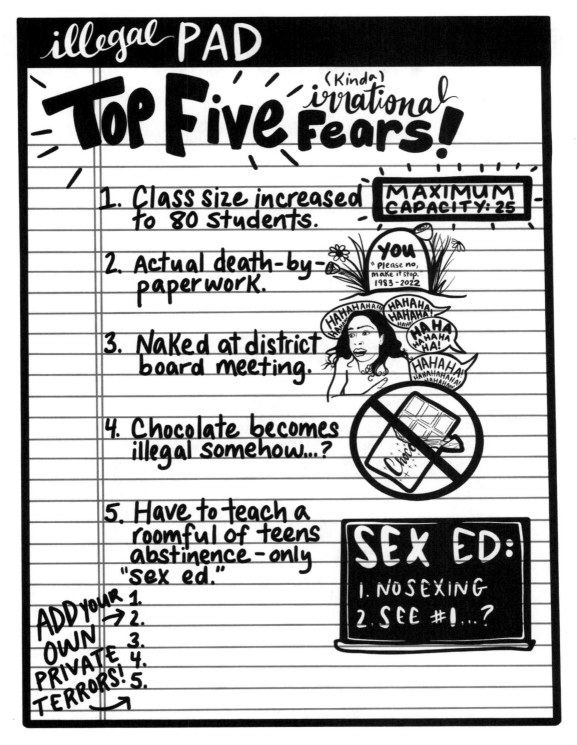

THE TEACHER DIET

Two-year-old Snickers Minis

Questionable yogurt

Leftover surprise

Carol's birthday cake (carrot-flavored, #why)

Coffeepot dregs

Fingernails

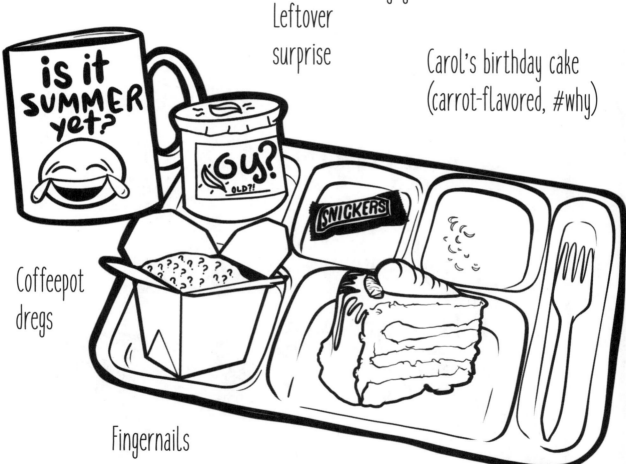

Also, ugh, this: _____.

And if I never eat this again I will be tenure-level happy: _____.

DRAW YOUR GO-TO LUNCH IN THIS CUTE BENTO BOX YOU BOUGHT FROM AN INSTAGRAM AD BECAUSE YOU'RE WORTH IT

MINIMALIST FLAT SPOON?

. . . Now add a few things* to make it *spectacular*.

*Like Yodels. Yodels make everything better.

TEACHERS FROM THE CRITTER WORLD, AWWWW

Fun fact: Rock ants, seen on page 40 being smart and creepy, were among the first proven "teachers" in the animal kingdom. When a rock ant finds a speck of food, she shows her buddies—one at a time—how to follow in her tracks by releasing pheromones, and then giving them a series of little taps when it's time to move on to the next lesson (aka the next landmark they have to memorize).

Pied babblers, an avian species native to the Kalahari Desert, teach their young to associate feeding with a "purring" sound that they make whenever they bring dinner. Later on, they can use these purrs to call the fledglings to them in case of danger, or to show them a good foraging spot. It's sort of like an all-natural dog clicker, but with an adorable sound instead of one that makes you feel like someone's snapping a rubber band on your eardrum.

Leveling up expectations for mothers-to-be everywhere, the superb fairywren actually begins teaching its offspring before they are born. While the eggs are still unhatched, the mother teaches the embryo a single, unique note—essentially a "password"—that the nestling must then repeat back if they want to get fed. Call and response FTW.

Adult meerkats teach their babies how to capture their own prey by bringing them dead scorpions with the stingers removed, and then, as they get older (and theoretically more competent at stinger removal), bringing them increasingly intact meals. The adults even let the babies fumble with and lose their prey from time to time, in service of helping them learn independence . . . until, one day, hooray! They're scorpion-killers all on their own.

Elephants live in matriarchal groups, and older females in the social group collaborate to teach their young how to nurse and walk. Just a friendly reminder from nature that it does, indeed, take a village.

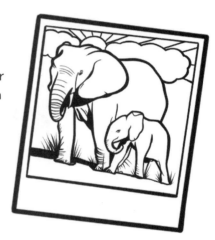

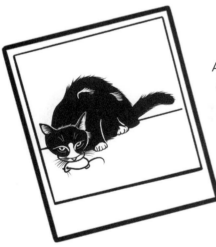

And finally: House cats, who famously bring their owners dead bunnies and such. Why? Because they are of the opinion that their owners are not humans, but rather wildly incompetent fellow cats who must be helped if they are to survive. Aww.

CONNECT THE DOTS TO REVEAL THE TINY TEACHER

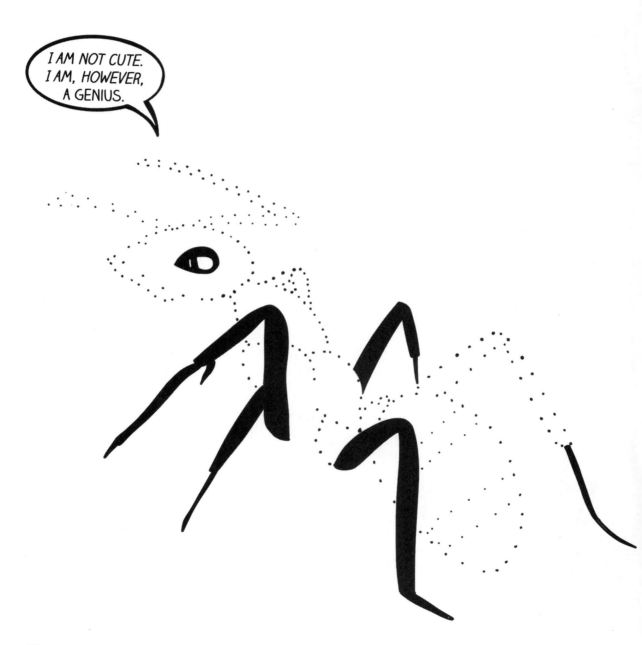

WORD LADDER: SNOW DAY, YAY

How many words can you make out of each of the below, changing only one letter every time?

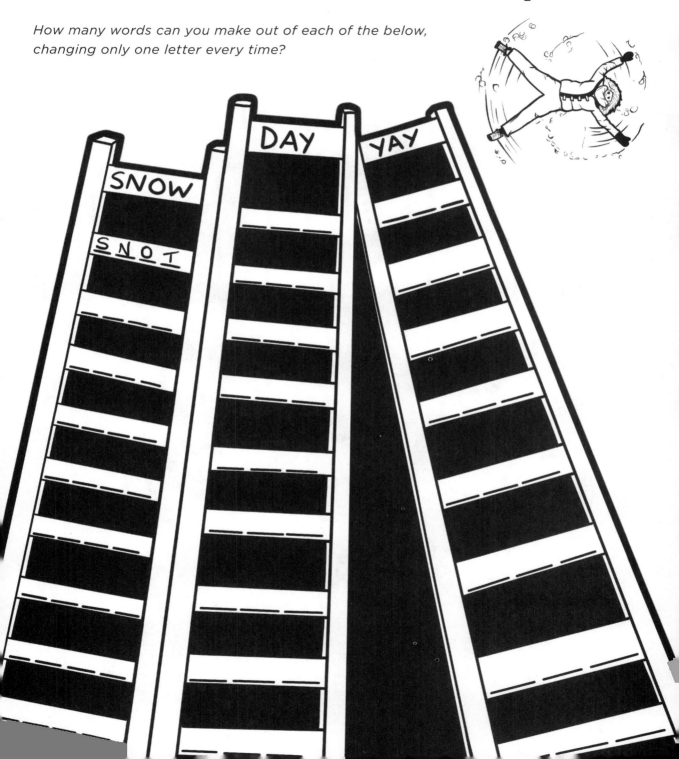

SNOW

SNOT

DAY

YAY

UNLOCK THE CODE TO REVEAL THE LIE YOU TELL DAILY

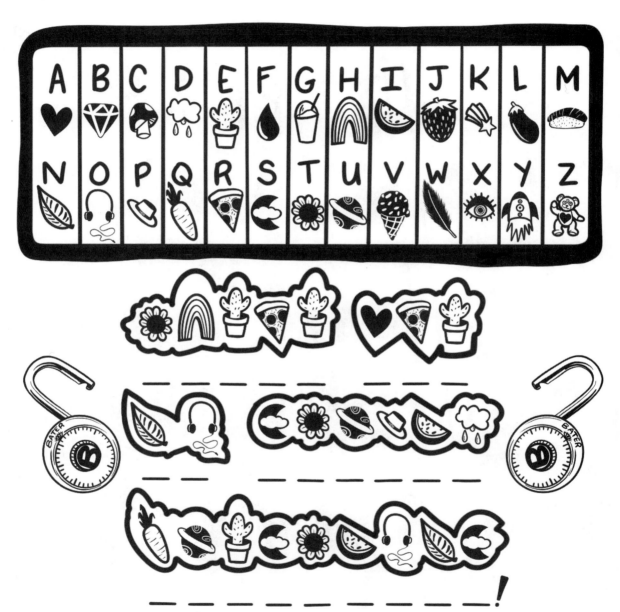

Answer: "There are no stupid questions."

HOW MANY WORDS CAN YOU MAKE OUT OF THE LETTERS IN "GROWTH MINDSET"?

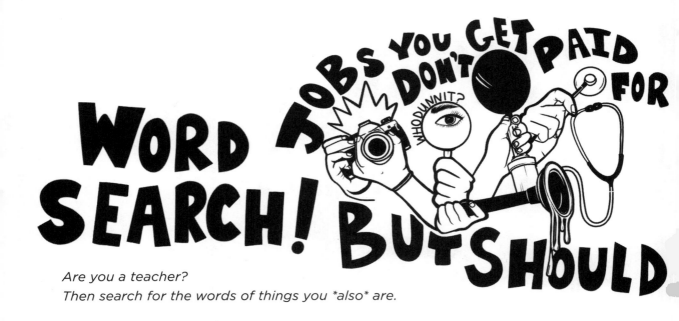

WORD SEARCH!

JOBS YOU DON'T GET PAID FOR BUT SHOULD

Are you a teacher?
*Then search for the words of things you *also* are.*

Counselor	(average US salary: $75,905*)
Mediator	($51,710)
Traffic controller	($79,740)
Nurse	($64,250)
Detective	($67,576)
Comedian	($42,822)
Custodian	($31,000)
Referee	($35,575)
Interior decorator	($43,343)
Epidemiologist	($79,240)
Party planner	($55,939)
Photographer	($66,825)
IT person	($63,524)
Plumber	($58,460)
Paramedic	($45,173)
Hero	(Priceless)

Now add up all those numbers to find your true job value: _____.
Feel free to bring this page to your next performance review.

*According to the Internet, so ¯_(ツ)_/¯

```
Q G T I N T E R I O R D E C O R A T O R Y Z X S O N P C G P
A N R F W E N A A N G T F P R P A I I I U H J K U L A I Q X
W K A R D A O A N C F R P M I C O U N S E L O R H U R D F X
R H F B V R R J I L G P I I W D P N J E Y L S L D K T E S J
N R F G E J T R U D V G A Z W H E N T C Q E S F S X Y M D A
A R I H G F K M S F E A K D O P P M H K Q Y Z I U Q P A H K
S V C M H Q S K L N K M S T A W D E I Q I U P Y Q Q L R O D
L J C E C G R U E N B V O D O D X W N O S R E P T I A A S A
W J O H Y N J V X M E G R C L Q C F Y F L U W K B V N P M S
M Y N X O C O E B R R P T E N T T O J X E O G J E B N Q X F
Q H T R D I U X X A W V L E B S S W J X P K G W V S E R Y K
O Z R X T E G H P R J G H W X M S K O B F Q Y I N I R P A Q
R T O M F C Y H R J X I N Q D T U B O X N C B B S C P V J C
T B L V P K E Y I G C F G Z F I U L O F A X A X V T L D W G
R K L G V R X N E V I T C E T E D C P C I Q I C R M R Z C N
B L E Y X P E C S B L V D M G M T B G D D G A I K G J T T D
B M R V H K Y J B M V G X G C G Y Q O D O E A T Q P Z C T H
L A O Z D X C Q K M K I G X I H V V W T T J E Z Q D F D H T
F O M R D R Y U M C E B W M J V Q Q O R S H F F I S Q Z S H
U J F E K V C O C B W F A C D C T O E B U L A I E M J F Q M
D K X C D C T E T M A D D V Z O N T C H C Y F H D P L N W J
B G D F B I E Q H F J O W B B Z M O K C H C G C C S P N C I
Z V P C J R A I Q S A A Q O Q J N N O I D C Z Y Y I F E Q I
B H G Q E U O T E I G Q E Y W U J C R F Y G Z C F L B W X G
J B D F R C D M O C A Q C Z N H Z D L R J O C X Z O A A B E
Y O E A E H B Z L R G U R Q X W X S V Y I U U A W W V F B Z
V R D B U I S M Z N V N E T Y S W I S Y Q Y Q N L K O Q E B
U B J V H V U W J G N M V T D T R P S B U N Y O J M Q A Z U
H U C T M M R Z X W C B D P C F F G L I R N J S V U V Y P B
G H A K B X M V I J Z D G Q H V O U D T Z K N O L J A C X F
```

HOW TO:
CONVINCE YOURSELF YOU DON'T HAVE TO PEE, LIKE, RIGHT NOW

The average adult bladder can hold about 1 ½ to 2 cups of urine. You, alas, just drank 4 cups of coffee and are smack in the middle of a lecture on number theory. What to do? Circle all the techniques you've tried.

Think about groceries. You need groceries. You also need toilet paper. Don't think about that.

Take deep breaths. Imagine your pee coming out of your mouth with each exhale. Don't tell anyone about this.

Kegels, sure.

Meditate. "I am in a dry desert. A dry, dry desert. There is only sand. There is no water. No water anywhere. Water doesn't even exist." Stop thinking about water.

Stay perfectly, perfectly still.

Move really a lot.

Don't. Laugh.

Just give up imbibing liquids full stop, forever.

P.S. If any of the above actually work for you, please send us an email with the subject line "I have figured out how to cure myself of basic human needs with an activity book."

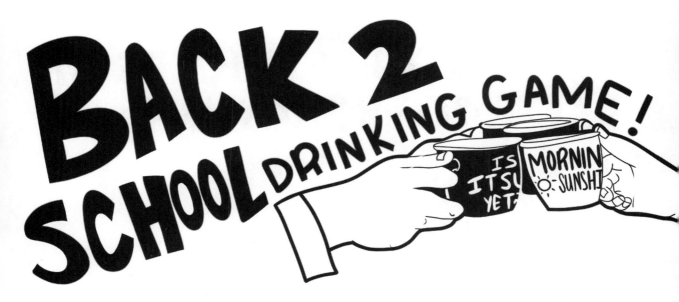

BACK 2 SCHOOL DRINKING GAME!

Actual tequila is (inexplicably) frowned upon on school premises, so we will be drinking shots of coffee (or espresso if you're feeling wild) for this Back-to-School Night themed game.

Take a ~~shot~~ sip every time . . .

Parent asks "How is [MY child] doing?" in front of the entire class.

Parent asks you to describe your "educational philosophy."

Parent wants to know how you challenge "highly gifted children."

Parent thinks there's too much homework.

Parent thinks there's not enough homework.

Parent needs you to explain the Common Core.

Parent has opinions about the Common Core.

There's a super awkward divorced parent situation.

The entire family shows up.

Somebody "forgot" to silence their cell phone.

You notice that the room is OMG so hot.

DRAW YOUR CUTICLES ON BACK-TO-SCHOOL NIGHT

THINGS TO DO INSTEAD OF DESTROYING YOUR CUTICLES

*Ravaged fingernails will only transmit your anxiety to the small percentage of people in your classroom who haven't already taken note of your manic smile and excessively detailed PowerPoint presentation. If you're looking for a replacement compulsion, here are some things to try instead.**

- ☐ Sharpen all of the pencils with one of those manual gadgets from the 1950s. Sharpen them again, just in case.

- ☐ Play matchmaker for your colleagues (in your head, so you don't get called into HR).

- ☐ Remove all traces of earwax with a Q-tip. Are you positive you didn't miss any? Double check.

- ☐ Cut your own bangs.

- ☐ Find any and all pimples, no matter how tiny and insignificant, and pop them. Ignore the fact that you look worse now.

- ☐ Locate your significant other and/or best friend. Do this to them, too. What, they don't want their pimples popped? Ignore them.

- ☐ Doomscroll.

- ☐ Call your cell phone provider's customer service hotline. Try to have a productive conversation that comes to a satisfactory and mutually agreeable end.

- ☐ Find an ASMR account on Instagram. Stay there for a while.

- ☐ Make your own ASMR account. Make it private. Delete it after one day.

- ☐ Make a list of all the lists you need to make.

- ☐ Go to IKEA with someone you love.

*All of these things do, in fact, help you to not bite your cuticles. None of them are an especially good idea.

WHAT ARE THE PARENTS THINKING?

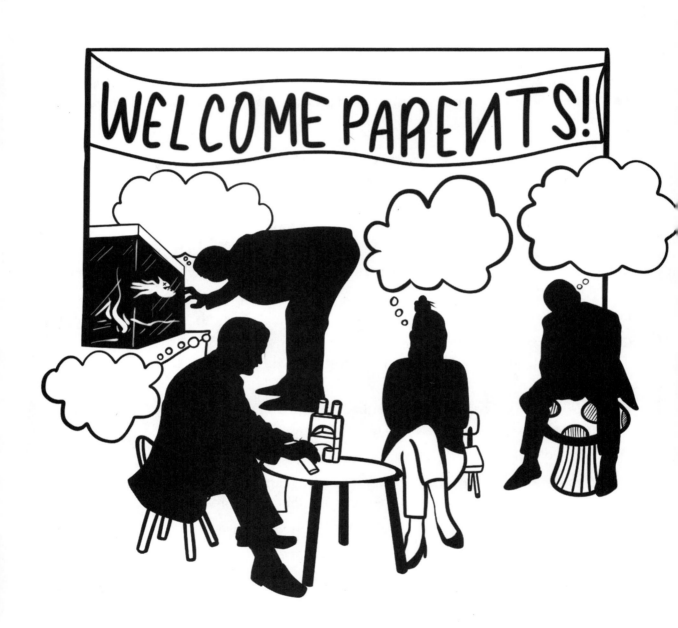

GET THROUGH THE BREAK ROOM OF HORRORS TO THAT DELICIOUS, DELICIOUS NESPRESSO

Avoid twelve-day-old doughnuts! Carol's crusty mug that she's "just going to use again, so what's the point of washing it"! Whatever the eff that is in the back of the refrigerator!

LET'S GET CAFFEINATED!

OMG SOMETHING DIED IN THE MICROWAVE

CEILING IS DRIPPING

SOMEONE NEEDS 2 VENT

EW! MYSTERY SPILL!!

WATCH OUT, DON'T USE CAROL'S CRUSTY TUMBLER!

ENGLISH TEACHERS GET LIT

VICTORY

COLOR IN THE COMPONENTS OF YOUR IDEAL WEEKEND

Lists and
lists and
lists

All the
donut holes

Postmates
tacos

Ancient
sweatshirt

Also these: 1._____ 2._____ 3._____ 4._____ 5._____

No children
anywhere

Total and complete
silence

PLEASE
DO NOT
DISTURB

Netflix
and naps

NETFLIX
+OPTIONAL CHILL

WORD SCRAMBLE: USELESS S*&T YOU HAVE TO TEACH ANYWAY

Your students will never, ever utilize the knowledge they acquire regarding any of the below. But they're gonna learn about these things anyway because YOU WILL NOT BACK DOWN IN THE FACE OF LOGIC OR REASON (and because, okay, it's your actual job description).

BASUCA

— — — — — —

TUFREYBLT SKERTO

— — — — — — — — — — — — — — —

GLON SIDONVII

— — — — — — — — — — — —

UICERVS

— — — — — — —

ECDRRREO

— — — — — — — —

PLARMGRSAOAELL

— — — — — — — — — — — — — —

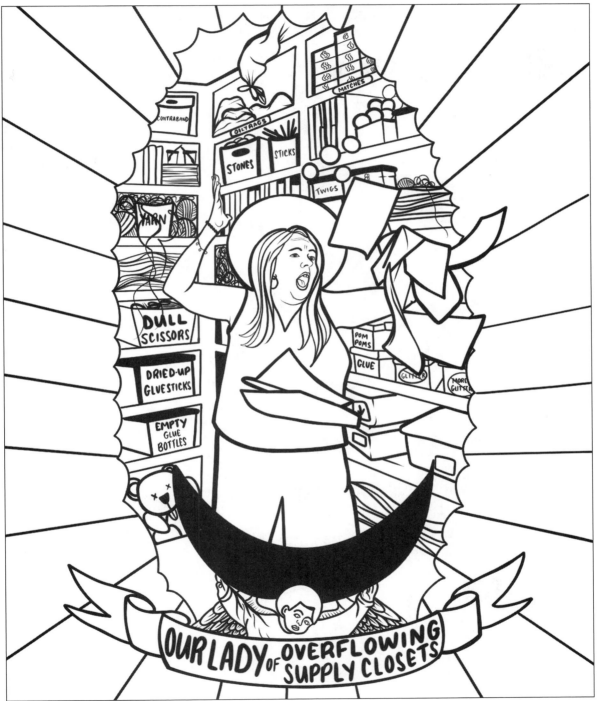

OUR LADY OF OVERFLOWING SUPPLY CLOSETS

SCAVENGER HUNT:
THE SUPPLY CLOSET

☐ Something you're super
 excited you just found

☐ Errant pom-pom

☐ Stuffed animal

☐ A push pin that
 definitely wants
 to hurt you

☐ One perfectly organized
 storage container

☐ Twenty-year-old glue stick

☐ Personal care item

☐ Something you realllly wish you hadn't just found

☐ At least three wires that plug into nothing in your classroom

☐ Abandoned craft project

☐ Styrofoam cup. Bonus points if it's chewed!

☐ Extremely old flash card

☐ Calendar from a year that is not this one

SIMPLE WAYS TO MAKE IT BETTER

There's no getting around it: Some days are straight awful. Not all of these things will help, but a few just might. Circle and color in your favorites.

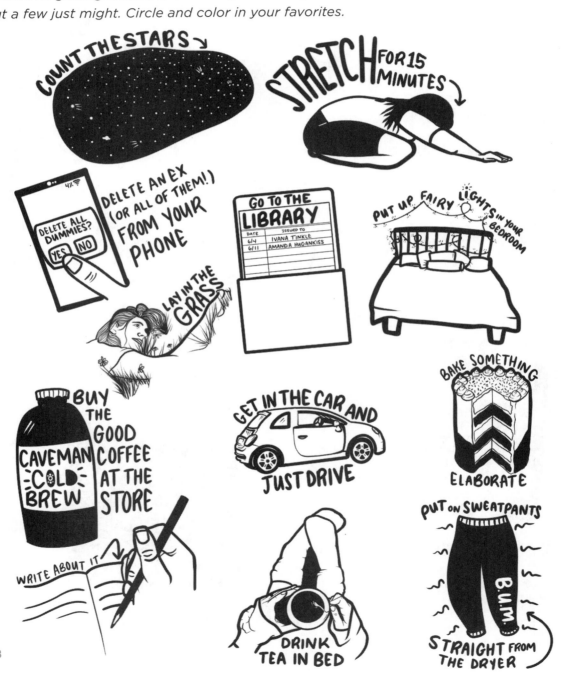

COUNT THE STARS

STRETCH FOR 15 MINUTES

DELETE AN EX (OR ALL OF THEM!) FROM YOUR PHONE

DELETE ALL DUMMIES? YES NO

GO TO THE LIBRARY

DATE	ISSUED TO
6/4	IVANA TINKLE
6/11	AMANDA HUGANKISS

PUT UP FAIRY LIGHTS IN YOUR BEDROOM

LAY IN THE GRASS

BUY THE GOOD COFFEE AT THE STORE

CAVEMAN COLD BREW

GET IN THE CAR AND JUST DRIVE

BAKE SOMETHING ELABORATE

WRITE ABOUT IT

DRINK TEA IN BED

PUT ON SWEATPANTS

B.U.M.

STRAIGHT FROM THE DRYER

BURN THE *FANCY* CANDLE
LEATHER + wisteria N' STUFF

MAKE SOME HOMEMADE SOUP

PET YOUR CAT

DANCE LIKE A SECRET MANIAC

SPACE OUT FOR A WHILE

ORGANIZE YOUR BEDSIDE TABLE

TAKE A NAP WITH YOUR DOG

TAKE A NICE LONG WALK

TURN OFF SOCIAL
LOG OFF
MEDIA FOR A DAY

DELETE SOCIAL MEDIA FULL STOP
DELETE 4-EVA

LISTEN TO 80s ERA MADONNA

Dumbfood
EAT AN *ENTIRE* BAG OF POPCORN

wisest sage 21:42
CALL YOUR MENTOR

WHAT YOU GET

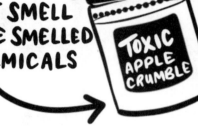

CANDLES THAT SMELL LIKE PIE, IF PIE SMELLED LIKE CHEMICALS

TOXIC APPLE CRUMBLE

ALL THE TINY SUCCULENTS THAT WILL SOMEHOW DIE INSTANTLY DESPITE BEING SUCCULENTS

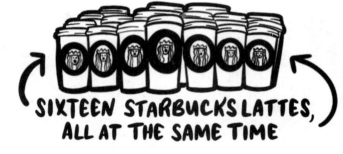

SIXTEEN STARBUCKS LATTES, ALL AT THE SAME TIME

AN APPLE COZY

YOU'RE ONE IN A MELON!

...THIS?

WHAT YOU NEED

BASIC SCHOOL SUPPLIES

PUBLIC SUPPORT FOR YOUR UNION
(AT RALLIES! ON FACEBOOK!
IN THE VOTING BOOTH!)

VOTE

DEDICATION TO VOTING FOR
POLITICIANS + POLICIES THAT SUPPORT
ROBUST FUNDING OF PUBLIC SCHOOLS

HELLO my name is Volunteer

VOLUNTEER HOURS
FOR ALL THOSE UNGLAMOROUS
JOBS THAT REALLY NEED DOING

PAY TO THE ORDER OF: YOU

A SALARY THAT ISN'T GARBAGE

Hooray! It's officially the week when everyone tells me how _____ I am!
ADJECTIVE

When I arrive at my classroom on Monday morning, I immediately notice that it

smells _____. Sitting on my desk are some _____ _____. My
ADJECTIVE ADJECTIVE PLURAL NOUN

students file in carrying their _____, and they're all _____. So
PLURAL NOUN VERB ENDING IN -ING

_____! They _____ to their seats. "_____!" one of them says.
ADJECTIVE VERB EXCLAMATION

"You're the most _____ teacher ever."
ADJECTIVE

For lunch, _____ surprises me with _____ and a big cup of
PERSON FOOD

_____. My favorites! Of course, all my students give me _____. I get a
BEVERAGE PLURAL NOUN

candle that smells like a/an _____, a mug for my must-have _____,
NOUN BEVERAGE

a/an _____, and a/an _____ for my _____. Also! The parents
ARTICLE OF CLOTHING NOUN PLACE IN A HOUSE

all got together, and each contributed _____ dollar/s to buy me a gift card to
NUMBER

_____.
STORE

The good news doesn't end there. The school administrators gave each of us a

_____, and increased our salary by _____ dollar/s. "You are so
NOUN NUMBER

_____," my principal said. "You deserve it."
ADJECTIVE

Wow. I just feel so _____. I can't wait to go home and _____.
ADJECTIVE VERB

ohhhhhh...

USE THE LETTERS IN
silence
TO COMPLETE THE WORDS!

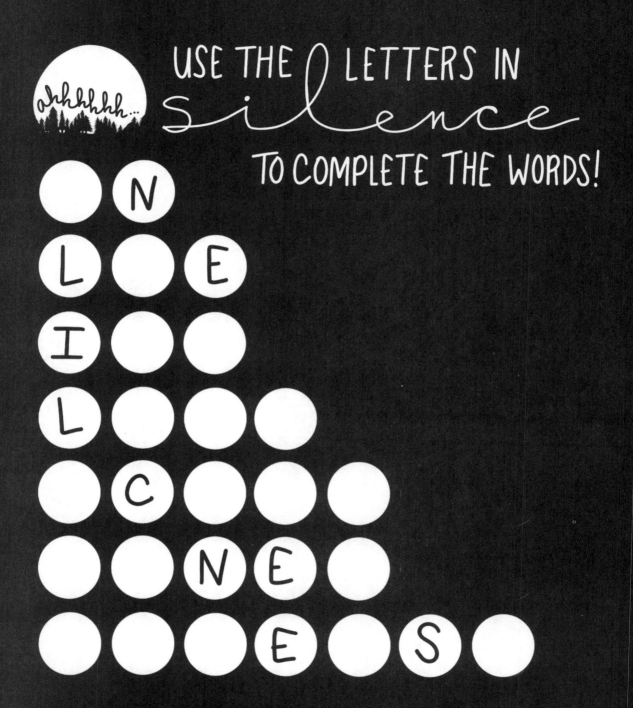

YOUR CART WHEN YOU RUN INTO YOUR STUDENT AND / OR THEIR PARENT AT THE STORE

Pregnancy test

Squatty Potty

Fifty Shades of Grey box set

Any condoms

XL Booze

Jonas Bros. LiVe

Tampon flask (it's a thing)

Cigarettes

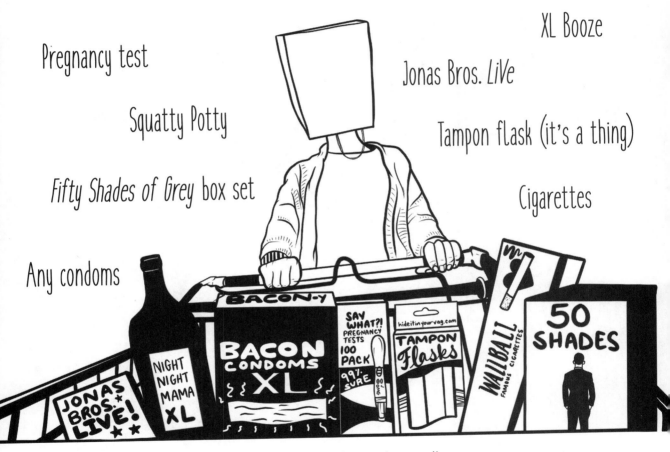

A few things I am oh my goodness so grateful I can buy online:

1. _____
2. _____
3. _____
4. _____
5. _____

TOP FIVE
TOTALLY RATIONAL FEARS

Internet broke

Laminator broke

Copier broke

Ran into student
at a pool

Carpet smells

Also these:

1. _____
2. _____
3. _____
4. _____
5. _____

COLOR IN THE SOGGY RAINY DAY CLASSROOM

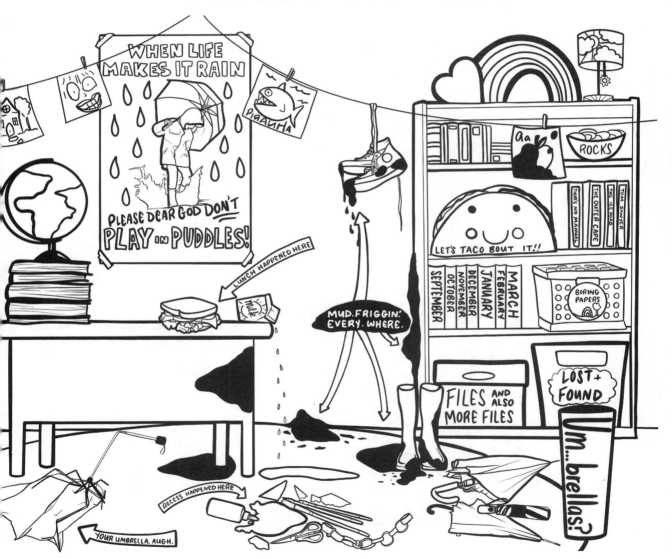

(KINDA?) DECENT TEACHER JOKES

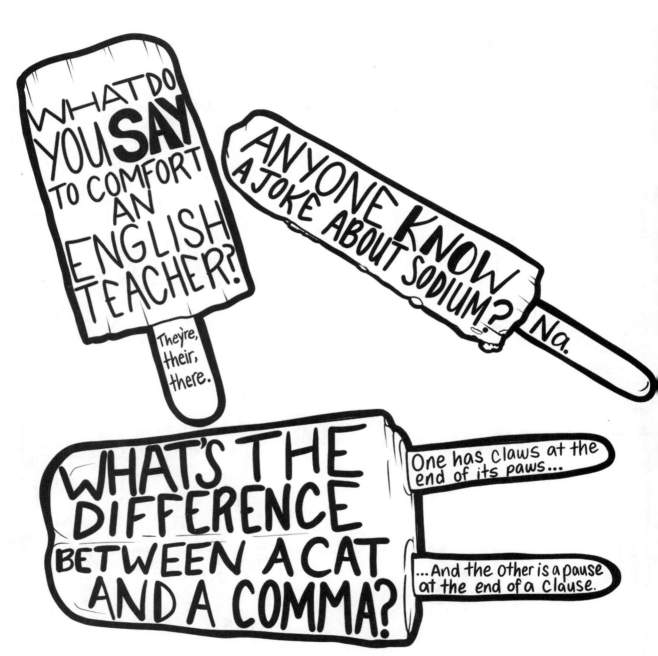

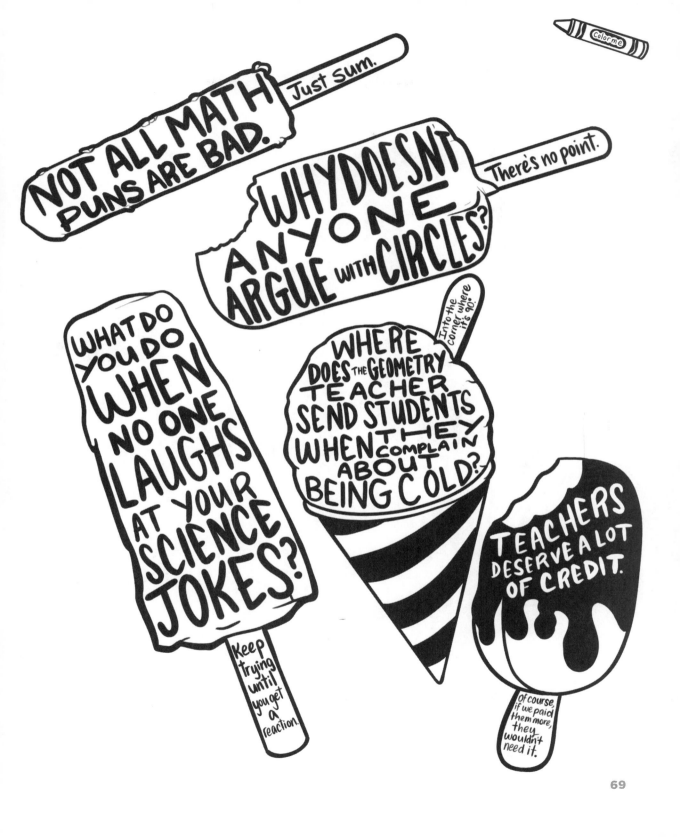

NOT ALL MATH PUNS ARE BAD.

Just sum.

WHY DOESN'T ANYONE ARGUE WITH CIRCLES?

There's no point.

WHAT DO YOU DO WHEN NO ONE LAUGHS AT YOUR SCIENCE JOKES?

Keep trying until you get a reaction.

WHERE DOES THE GEOMETRY TEACHER SEND STUDENTS WHEN THEY COMPLAIN ABOUT BEING COLD?

Into the corner where it's 90°.

TEACHERS DESERVE A LOT OF CREDIT.

Of course, if we paid them more, they wouldn't need it.

Color me

GRAMMAR: IT'S NOT THAT HARD

Match the infuriatingly incorrect slogan to the brand logo

. . . then scribble over the unacceptable slogan with the correct way to say it.

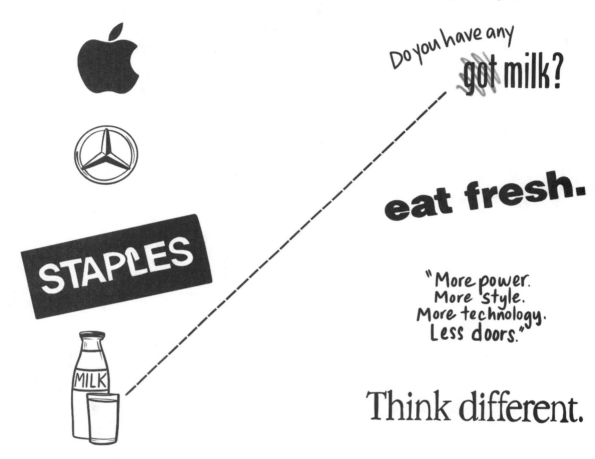

Do you have any ~~got~~ milk?

eat fresh.

"More power.
More style.
More technology.
Less doors."

Think different.

Yeah, we've got that.

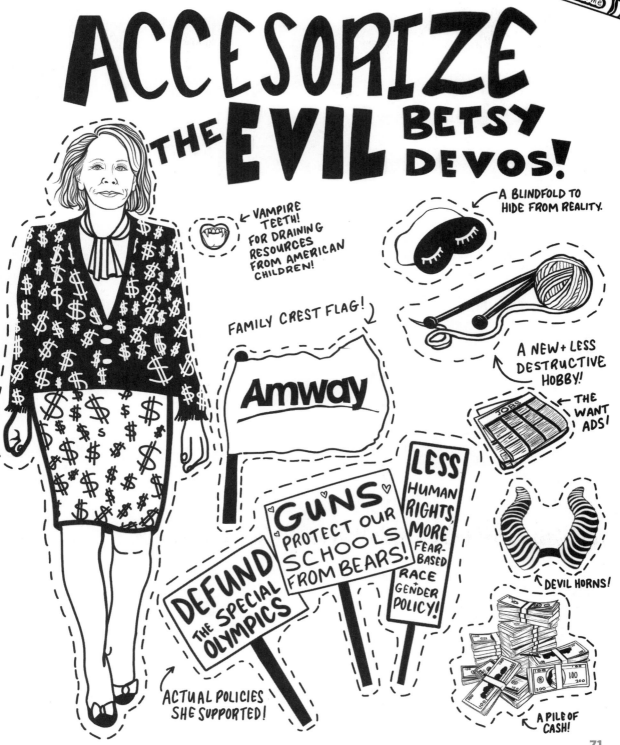

ACCESORIZE THE **EVIL** BETSY DEVOS!

← VAMPIRE TEETH! FOR DRAINING RESOURCES FROM AMERICAN CHILDREN!

A BLINDFOLD TO HIDE FROM REALITY.

A NEW + LESS DESTRUCTIVE HOBBY!

FAMILY CREST FLAG!

Amway

← THE WANT ADS!

LESS HUMAN RIGHTS, MORE FEAR-BASED RACE + GENDER POLICY!

GUNS PROTECT OUR SCHOOLS FROM BEARS!

DEFUND THE SPECIAL OLYMPICS

DEVIL HORNS!

ACTUAL POLICIES SHE SUPPORTED!

A PILE OF CASH!

Color me

71

PAGE INTENTIONALLY LEFT BLANK

TOP FIVE
PANTS ALTERNATIVES
(AKA THE BEST THING 2020 TAUGHT US)

LIMIT 5 ITEMS

Pants are awful. Especially ones with buttons. Draw your top 5 go-to distance learning lewks here:

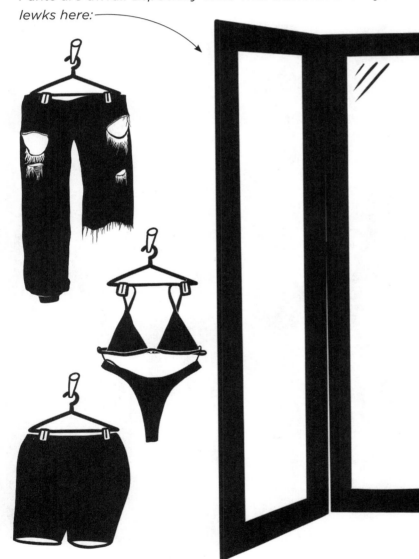

DRAW THE HAIRCUT OF YOUR OFF-DUTY DREAMS ON THIS GLAM COSMETOLOGY BUST

Sure, your look is probably more along the lines of "practical" and "please don't pull on me" during working hours. Draw the style you would (or do) rock when it's time to par-tay.

TEACHER MERCH YOU ~~SHOULD~~ CAN GET ON AMAZON

A button to let your students know when you are DONE.

This book, hooray!

A napsack, yes.

A pen that yells at people for you.

STD-themed plushies, because if you're going to talk about herpes, might as well make it cute.

A Bob Ross bobblehead (clearly essential).

NEVER HAVE I EVER

Grab your fellow teacher besties and some dranks, and sit down for this glorious old-school game. If you've never played before, here's how it works: You drink if you did it. Since you have likely done many of these things, start with shots of kombucha instead of Jack—hangovers in homeroom are nobody's friend.

Had a relaxing lunch with zero interruptions

Secretly wished two of my students would just start dating already

100% had a favorite student

Forgot to drink water for an entire day

Enjoyed laminating more than most things in my life

Yelled "NO RUNNING!" at a random child in a public place, because #habits

Pretended not to get a parent's email/voicemail/note

Had a student use my sleeve as a tissue

Spent exactly the amount I planned to spend at Target, and not a penny more

Spent an entire weekend correcting papers

Saw a wet spot and cleaned it up without thinking too hard about what, exactly, it might be

Yelled at the copier, even though copiers aren't people and cannot hear you

RANK THE EMAILS THAT YOU DO NOT NEED IN YOUR LIFE FROM 1 (NO) TO 5 (NOPE NOPE NOPE NOPE NOPE)

INBOX

🔍 SEARCH

1-5:

SUBJECT: FYI MAY 14
TYLER THREW UP ALL NIGHT BUT SEEMS FINE NOW, SO JUST LET ME KNOW IF THERE'S A PROBLEM!

☐

SUBJECT: FYI MAY 1
WE'RE TAKING TYLER ON A TWO-WEEK VACATION STARTING TOMORROW, SO PLEASE LET ME KNOW A GOOD TIME TODAY TO PICK UP A WORK PACKET!

☐

SUBJECT: FYI APRIL 29
I WAS THINKING YOU SHOULD PROBABLY FOCUS MORE ON STANDARDIZED TEST PREP, SO I WENT AHEAD AND LET THE DISTRICT OFFICE KNOW!

☐

SUBJECT: FYI APRIL 29
I NOTICED TYLER HASN'T BEEN DOING HIS HOMEWORK AND I WAS WONDERING IF YOU COULD TALK TO HIM ABOUT THAT!

☐

SUBJECT: FYI APRIL 29
I THINK TYLER SHOULD SKIP A GRADE.

☐

MATCH THE SCHOOL-THEMED SONG TO THE SINGER

1. "School's Out"

2. "Hot for Teacher"

3. "Beauty School Dropout"

4. "Don't Be a Dropout"

5. "Rock 'N' Roll High School"

6. "Be True to Your School"

7. "High School"

8. "School Days"

9. "Teacher Teacher"

10. "Schooldays"

11. "Master Teacher"

A) Chuck Berry

B) Frankie Avalon

C) James Brown

D) Alice Cooper

E) The Kinks

F) Erykah Badu

G) Kelsea Ballerini

H) The Ramones

I) Rockpile

J) The Beach Boys

K) Van Halen

WORD SEARCH Retro TEACHER TOOLS!

Thanks to digital advances, today's classrooms look a whole lot different than they used to. (Pour one out for the TI-82*.) If you're under the age of thirty, you may not even know what some of these things are.

Find the items that used to be schoolroom essentials, but these days, not so much.

Rubber cement

Dictionary

Encyclopedia Britannica

Dewey Decimal System

VCR carts

Chalk

Wite-Out

Word processors

Floppy disks

Microfiche

Transparencies

Slide projectors

*Don't know what this is? Congratulations on your youth.

```
T Y E T P K G X E P R S E I C N E R A P S N A R T I L D A J
Q N C M V D S W R N U P O R G Y F I J A P T I Q J J S J J V
E T N L S O O X V Q B B Y S A I E S P T L P X I E M X L Z X
N A U J B T Q H H M B L G S N K C Z E C X X R G F E J H J Y
Q K R V U M N O S Q E H G Y V I E P F A R Z M N G L U C L M
O P T Z H M L B H K R T Y D G F T P Z J B Y F R U C X X Q Q
H X V Z X X H W L P C S S O D T B I T F R F W U W Z F M
C K E S C J M R O Y E W Q Y N F T R I G X K H D D Y U R L P
Q D D I S X Z R K V M B S Y S N T Y L M T Q J J G E R K O P
Q D X P R P D Q O S E O J Y W L Z E H F S Q Y W J P I L P Q
H U G J N O A C I N N A T I R B A I D E P O L C Y C N E P N
N A C D L P Y I S Z T T E F B N W M R Z O U I M Y R V K Y G
V J F H D W A Z O V W R R A F W A E I D J P V Y D C S J D D
W I T E O U T A W J V O D S M L X C S C G N S D L A T E I S
M I P N G K Y D E P L S R U P Y Y Y P B M E X Q P Q I R E S O
N S C D X L G O H R H Y P D F P S M U Y I D E P Z G A S K J
Q F R C U L X X O O Z E D Q P T F L K L M M Y G P H C W S B
N E N O X K A M G P H K Z V X R R T G V V P W E G L R U C K
G E J H T U E H R M L S Y P U R O D R R H F S O W C C S H A
W T L X A C J M I D X Z D D G V I C F I F T W N H E V F P S
T P V Q H M E C F I D G T Y P C H D E U G G A G K P D L H O
J A J J N M R J I T J Y X J T R Z K Z S O H R J T J N J W Q
O S A K V O L T O T S Q N I T D L L N T S B R A S L Q N X P
O L J Q F D L O H R Y P O T E A Z C B S S O I Q L J C T F F
Q B J I W N D G W Q P N H M H R B O O I B M R D C V S U J L
S J C X G W K G G P A E O C J O J V S B C G B S K T S T G J
Z H L R C Z L M Y R X E D G C E M S N V F X D E U A R V X O
E E Z X O R V R Y G U Q N I E G Q D N W X B V U N R S U M E
V L J I J P I Q D R E V S D L J W M H Q K W J K X L C H J E
L Q V B Z V B G J Z C L T W M S B M G S S O Z W M H V D L M
```

TURN THE WEIRD SQUIGGLE INTO A GOOD THING!

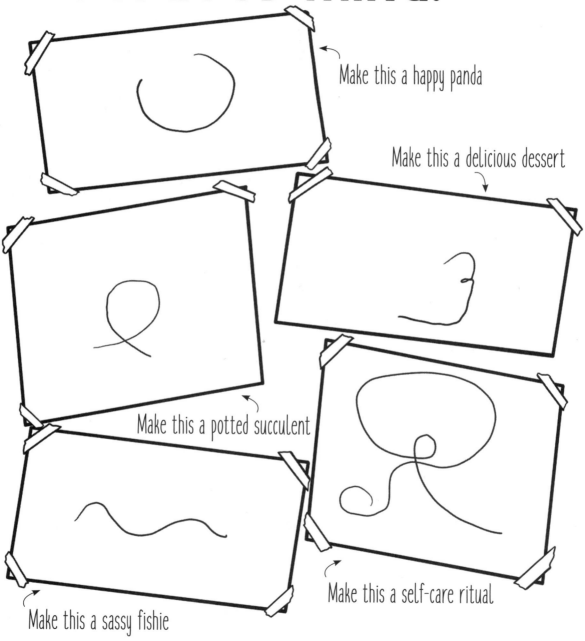

Make this a happy panda

Make this a delicious dessert

Make this a potted succulent

Make this a sassy fishie

Make this a self-care ritual

COLOR IN THE HELICOPTER PARENT WHO NEEDS TO STOP EMAILING YOU, LIKE, RIGHT NOW

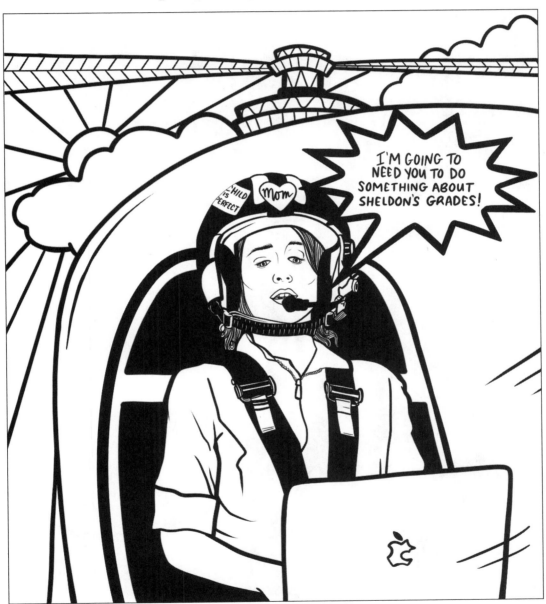

HUNT: YOUR CLASSROOM

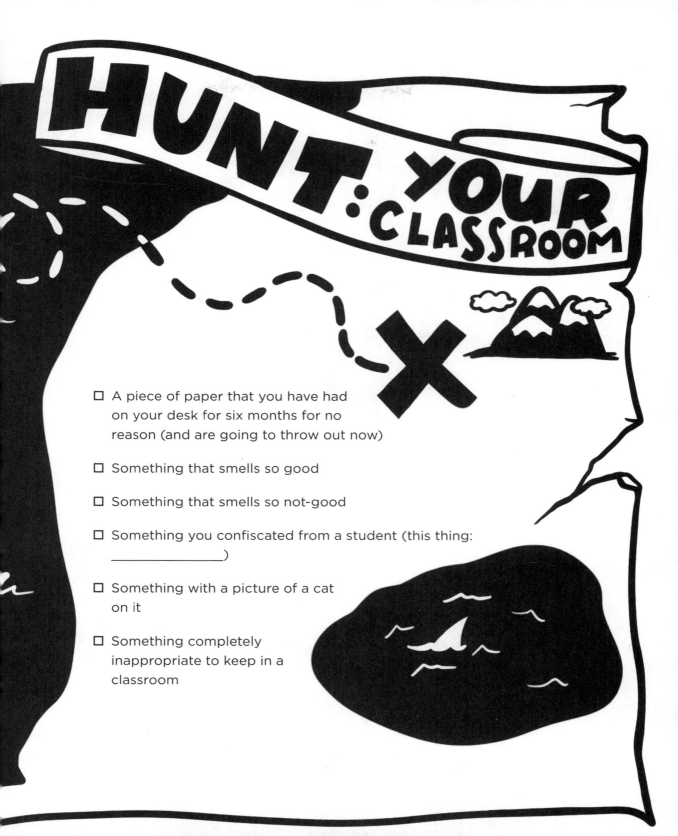

- ☐ A piece of paper that you have had on your desk for six months for no reason (and are going to throw out now)

- ☐ Something that smells so good

- ☐ Something that smells so not-good

- ☐ Something you confiscated from a student (this thing: _____)

- ☐ Something with a picture of a cat on it

- ☐ Something completely inappropriate to keep in a classroom

DECORATE THE BIRTHDAY CAKE A PARENT BROUGHT IN WITH NO PLATES OR UTENSILS WHATSOEVER

THINGS YOU THINK ABOUT AT THREE A.M.

1. The enormity of the numbers associated with your student loan interest, and the age at which you will pay it off.

2. Are you out of ramen?

3. How much ramen is too much ramen?

4. Why is ramen so delicious?

5. What if the Wi-Fi is down what if the Wi-Fi is down what if the Wi-Fi is down?

6. How Carol was coughing by the coffeepot and now your throat is feeling scratchy, too.

7. Please stop doing that, Carol.

8. How if you fall asleep right now you can still get three hours of sleep.

9. When your students fart near you, does that mean you're breathing in little bits of poop?

10. You sent that email to the Frankie in IT, not the Frankie who dumped you in 2006 . . . right?

11. Bedbugs.

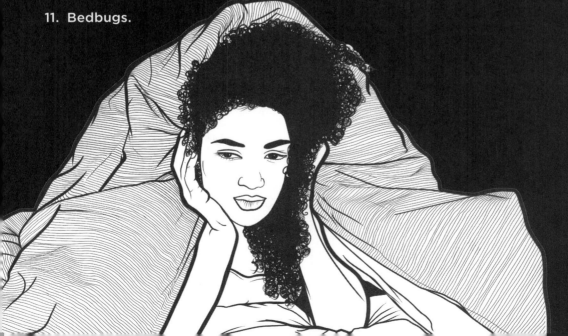

DRAW your FUTURE

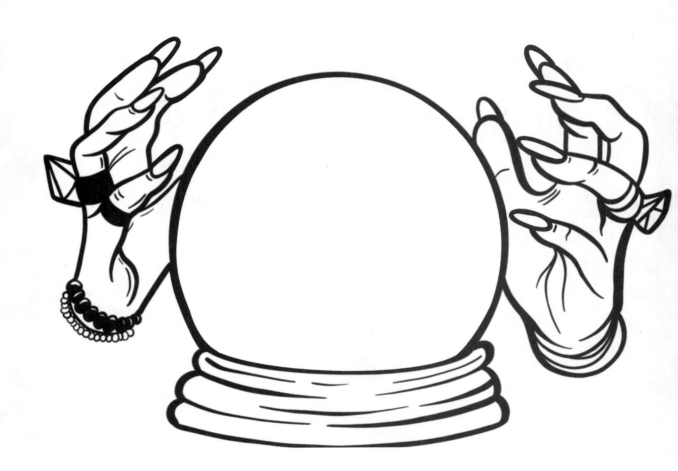

WHAT TO DO WITH A MUG (BESIDES THE OBVIOUS)

You've got fifteen thousand of them. Might as well put them to work.

Fill with birdseed
→ Budget bird feeder

← PLEASE DO THIS

Regift to other teachers,
just to see the expression on their faces

Fill with
rocks → Instant doorstop

SIN FANDEL

UR DINO-MITE!

Fill with wine → Surreptitious wineglass
Never mind, you already do this

World's greatest GYM TEACHER

Fill with scented wax and
a wick → Adorable candle

Throw against
wall → Stress relief

YOU KNOW YOU'RE A TEACHER IF YOU . . .

Check off all the behaviors you know oh so well.

- ☐ Will eat any baked good you find in the break room, irrespective of its age
- ☐ Are capable of writing entire sentences on a board without ever turning your head to look at them
- ☐ Never, ever hear an excuse you haven't heard before
- ☐ Know with complete certainty that the dog did not eat it
- ☐ Own an actual gift shop's worth of frames, candles, and stuffed animals
- ☐ Think Teacher Appreciation Week should be, um, *all year*
- ☐ Have had a student tell you something about their parent that you seriously did not need to know
- ☐ Say "I'm not an artist" before you begin drawing something
- ☐ Constantly purchase basic supplies for your classroom with your own money
- ☐ Never sit down without checking your seat first
- ☐ Can sense a student using their cell phone somewhere in the depths of your soul
- ☐ Feel like you deserve to own stock in a paper company
- ☐ See the potential in every student and care (a lot) about bringing it out

DECORATE THE MEDAL YOU CLEARLY DESERVE

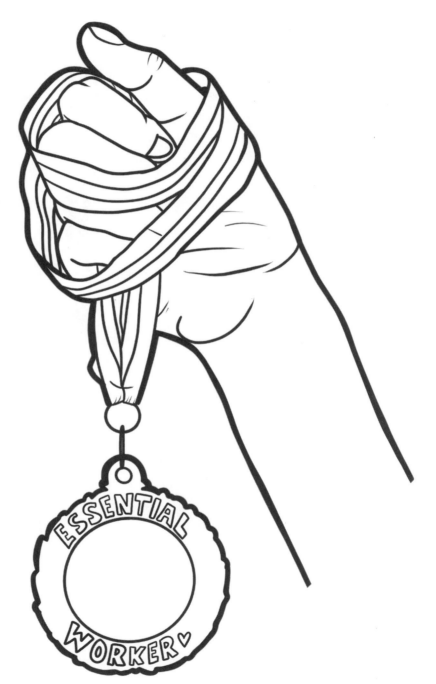

MOVIES THAT WOULDN'T EXIST WITHOUT
TEACHERS

Imagine a world without *Kindergarten Cop*! You can't do it; it's too sad. Unscramble the names of the other movies that you can take partial credit for, because why not.

Bonus: Can you name the lead actor in each of these movies?

HOW TO:
HANDLE THIS CONVERSATION WITHOUT YOUR BRAIN EXPLODING

A few options for your consideration:

"I know, right?! My personal assistant is always complaining about all those tests he has to grade and lesson plans he has to make, but that's why I keep him on the payroll, amirite? It's so important to have good help these days."

"Yup. The best part is getting to pee whenever I want."

"OMG, you should become a teacher!"

"Summers off are nice. It'd be nicer if I got paid for them, but hey."

"Thank goodness. Otherwise I don't know *what* kind of shape my tennis game would be in."

"Wait . . . *what*? I do?! Shut the front door."

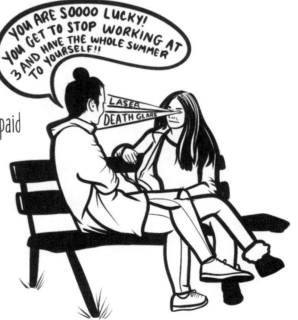

TEACHER FACTS

CIRCLE YOUR ANSWER!

T **F** 1. Almost one in six teachers leaves the profession after the first year.

T **F** 2. Surveys show that teachers in the U.S. place second on the list of occupations that contribute the most to a society's overall well-being, after politicians.

T **F** 3. On average, teachers make 7.5 percent less than individuals with similar levels of education in other professions.

T **F** 4. In some parts of California (ahem, Silicon Valley, ahem), newly graduated teachers would have to spend 129 percent of their salary to purchase a home.

T **F** 5. A 2020 salary.com survey found that the stress level associated with being a teacher is only slightly less than that associated with professions such as emergency dispatchers, police officers, and firefighters.

Answers: 1. False. It's almost one in three. 2. False. Obviously. The only occupation that ranks higher than teachers on this scale is military personnel. 3. False. The real answer is more than double that (19.2 percent). 4. True. 5. True. That said, we'll take a nice, relaxing two-alarm fire over a parent with access to our personal cell number any day.

CUT OUT THE SUMMER TEXT MESSAGES YOU DO NOT WANT TO GET AND DESTROY THEM

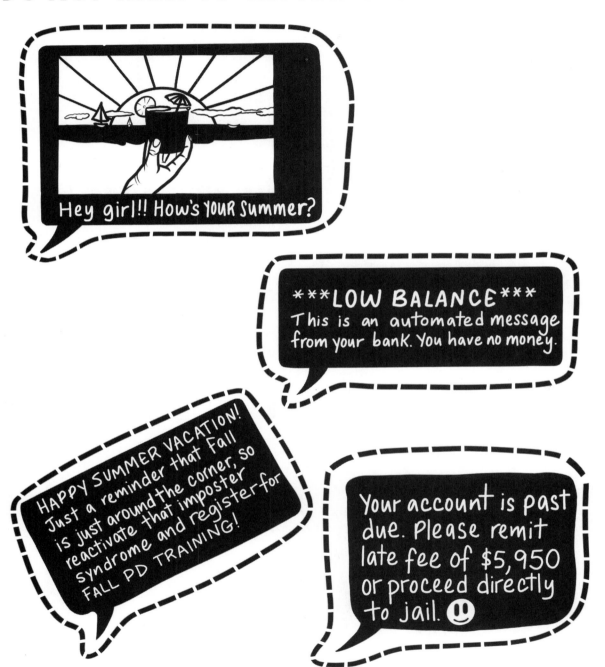

PAGE INTENTIONALLY LEFT BLANK

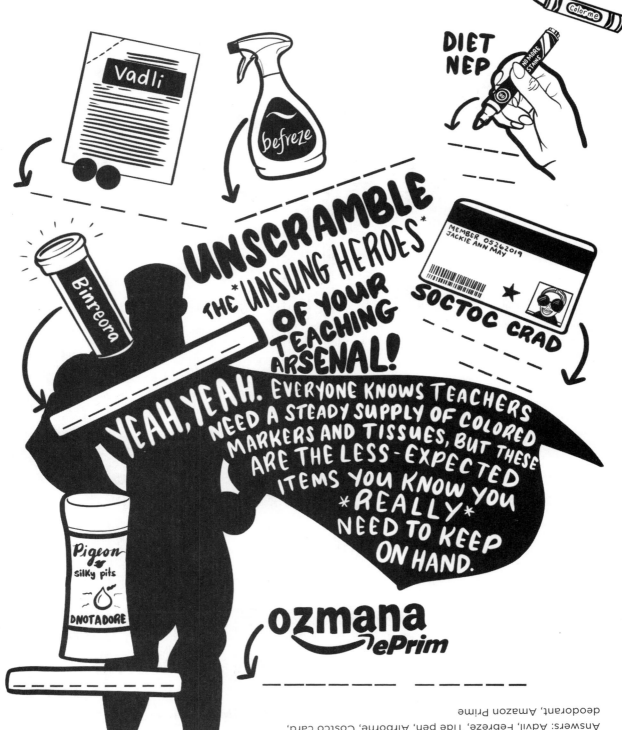

UNSCRAMBLE THE *UNSUNG HEROES* OF YOUR TEACHING ARSENAL!

YEAH, YEAH. EVERYONE KNOWS TEACHERS NEED A STEADY SUPPLY OF COLORED MARKERS AND TISSUES, BUT THESE ARE THE LESS-EXPECTED ITEMS YOU KNOW YOU *REALLY* NEED TO KEEP ON HAND.

Vadli

befreze

DIET NEP

Color me

MEMBER 05262019
JACKIE ANN MAY

SOCTOC CRAD

Binreora

Pigeon silky pits
DNOTADORE

ozmana ePrim

Answers: Advil, Febreze, Tide pen, Airborne, Costco card, deodorant, Amazon Prime

97

Color me

COLOR IN THE MAGNETIC POETRY ADJECTIVES THAT DESCRIBE YOU PERFECTLY!

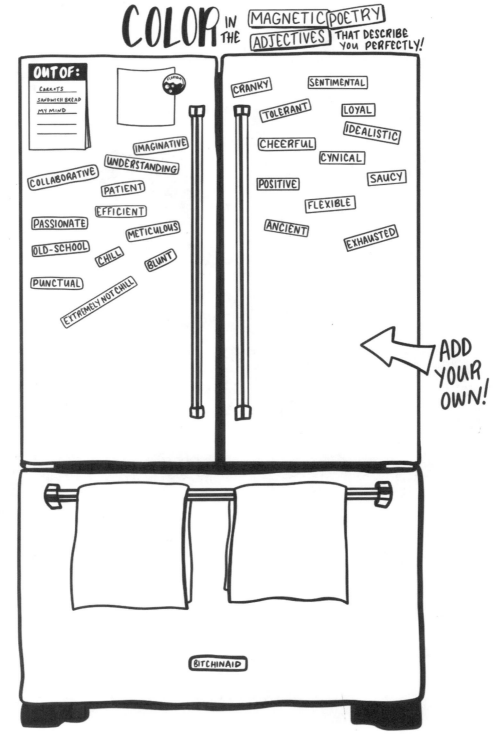

OUT OF:
Carrots
Sandwich Bread
My Mind

FLORIDA

IMAGINATIVE
UNDERSTANDING
COLLABORATIVE
PATIENT
EFFICIENT
PASSIONATE
OLD-SCHOOL
METICULOUS
CHILL
BLUNT
PUNCTUAL
EXTREMELY NOT CHILL

CRANKY
SENTIMENTAL
TOLERANT
LOYAL
IDEALISTIC
CHEERFUL
CYNICAL
POSITIVE
SAUCY
FLEXIBLE
ANCIENT
EXHAUSTED

ADD YOUR OWN!

BITCHINAID

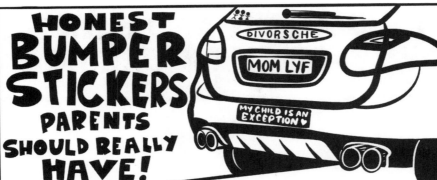

HONEST BUMPER STICKERS PARENTS SHOULD REALLY HAVE!

DIVORSCHE
MOM LYF
MY CHILD IS AN EXCEPTION ♥

MY CHILD ISN'T REALLY VEGAN, I'm just a pain in the ass.

HELLA KIDS UP IN THIS VAN!

PROUD -ISH PARENT OF A KID WHO IS AN ★Asshole★ LIKE 37% OF THE TIME.

WARNING: MIGRAINE ON BOARD!

YOUR → TURN!

Jesus Said: Mediocrity is a virtue, too!

BE A KID AGAIN AND FINISH THIS HAPPY (?) STICK FIGURE DRAWING

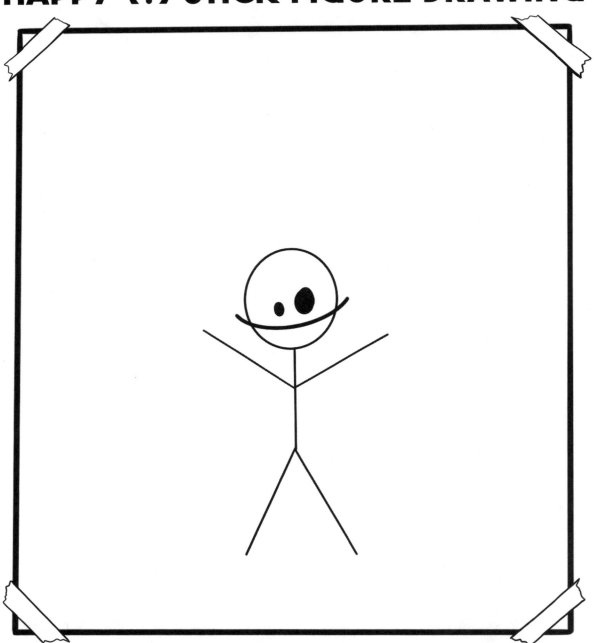

TOP FIVE
BEST THINGS ABOUT BEING A TEACHER

446

Pinterest browsing = professional development

Can win speed-eating contest

Always have a paper clip handy

Zero startle reflex

So much love

Also these things:
1. _____
2. _____
3. _____
4. _____
5. _____

SCAVENGER HUNT: AT HOME

☐ A distance-learning artifact

☐ A pen that doesn't work at all
(Bonus: Throw it out!)

☐ A mostly dead plant

☐ A sad sock that is
missing its mate

☐ Something that makes you smile immediately

☐ A burned-out lightbulb
(Bonus: Change it!)

☐ A "motivational" book
you obviously never read

☐ A pen that works

☐ A stray hair
(extra points if it doesn't belong to you)

☐ A remote, charger, or
cord for a device that you
haven't owned in a decade

☐ A spiderweb
(Bonus: Take Charlotte outside to live her best life!)

☐ An unidentifiable key

☐ A memento from
your college years

☐ Your favorite book that
you haven't read in
forever (Bonus: Read it!)

These are a few of my favorite things!

Sometimes the simple act of remembering what makes us feel good is calming. If this activity doesn't work, try drugs.*

Fill in your favorite things below.

Writing implement: _____
App: _____
Color: _____
Flower: _____
Plant: _____
Candy: _____
Household chore: _____
Road trip destination: _____
Fast food chain: _____
Sandwich: _____
Activity book: ___THIS ONE, **OBVIOUSLY**_____
Furry creature: _____
Beverage: _____
Book: _____
Ben & Jerry's flavor: _____
Time waster: _____
Dessert: _____
Person to call when I'm happy: _____
Person to call when I'm sad: _____
Self-care ritual: _____
Kevin Costner movie: _____

*Kidding! Unless they're prescribed by a licensed medical professional, of course.

SPEAKING OF BEN & JERRY'S . . .

Design the pint that would make all your dreams come true.

YOUR *SHARK TANK* SUBMISSION

A pencil that never needs sharpening? Wi-Fi that never goes out? Invent the thing that would make your life 1000000x better and draw it here.

Your FUTURE

CONFIRMED BY ASTROLOGY

Astrology: The practice of using the positions of celestial objects to make sense of the mess that's going on down below.

Aries: Ooh, you fiery thing, you. Your tendency to yell and demand things will lead you into a second career as a professional sports team mascot, or perhaps a politician.

Taurus: You were one of the few who flat-out loved 2020, thanks to the constant sweatpants-wearing and the fact that you got to hang at home, which is all you really ever wanted. Upon retirement (early, please), you will become a star pupil in a local sleep study.

Gemini: You are "dynamic," which can also be interpreted as "exhausting." You will order an endless series of elaborate paint-by-number kits on Amazon, none of which you will complete.

Cancer: Like Ariana Grande, you are a natural caretaker—until you hit your "Thank U, Next" point, which happens around 2:15 p.m. every afternoon. You love to ~~save things~~ hoard, and are destined to be the one your colleagues come to when they need extra Styrofoam cups for all eternity.

Leo: You are charismatic, stylish, and a little manipulative. You will write a bestselling how-to manual on how to always get your way, even in a room full of hormonal tweens with Snapchat accounts.

Virgo: You are essentially perfect. Well done. You will take this next-level by learning how to crochet tiny outfits to keep shelter pets warm, and also by going keto.

Libra: You are beautiful, charismatic, and social. You will become a high-profile Instagram influencer via your tutorials on how to make decoupaged pencil storage cases from old straws, thereby single-handedly saving the ocean.

Scorpio: In high school, you were famous for perfecting the Cool Locker Lean. You will find your true passion when you are cast in a supporting role in your local theater troupe's performance of *Grease*.

Sagittarius: You are the life of the party, which means that you are probably good at getting down to "Uptown Funk." You will make an "ironic" music video that will get millions of hits, and land you a sponsorship from Wendy's.

Capricorn: You are grounded and pragmatic, love following the rules, and secretly envy the hall monitor. You also enjoy responsibility, and will only retire if they drag you from your desk kicking and screaming (which they won't, because you're The Actual Best).

Aquarius: You are dreamy and floaty, like a human soap bubble. You will find peace on a commune where you can spend your days decorating your home with found objects and educating your friends on things like the history of ballpoint pens.

Pisces: You are emotional, imaginative, and famous for your habit of forgetting where you left your coffee cup. Your love of Sarah McLachlan music will lead you to discover a latent talent for extremely sad poetry.

DRAW YOUR BEDSIDE TABLE

Ah, the nightstand: Home of a thousand half-drunk glasses of water, partially graded essays, and books you'll get around to reading "someday" (aka when you retire). Draw what yours looks like right this moment, for posterity's sake.

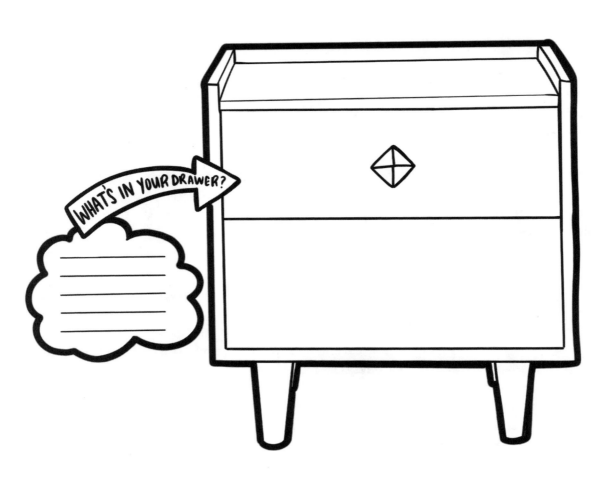

WHAT'S IN YOUR DRAWER?

GRATITUDE LIST

One of the best tools for getting through a rough day is a gratitude list. We realize that the last thing you want to do when you feel stressed is sit down and think about what you're thankful for, but unfortunately (fortunately!), it works.

Today, I'm grateful for:

I'm also grateful for:

The student who said/did this: _____

The colleague who said/did this: _____

This person, who helped me when they didn't have to: _____

This person, who I had the opportunity to help: _____

This thing about my home: _____

This thing about my job: _____

This thing about myself: _____

YOUR PERSONAL CAN'T-HANDLE LIST

Everyone has them: Things They Cannot Handle. Bugs with wings. The word "moist." Oat-meal cookies with raisins (aka disappointment in baked-good form). Check the appropriate column for each thing below.

THING	CAN HANDLE	CAN'T HANDLE	SECRETLY ENJOY
Wite-Out smell			
Clapping chalkboard erasers			
Running into a parent outside school			
Running into a student outside school			
Running into a colleague outside school			
Cafeteria pizza			
Staple removal			
Laminating			
Copying			
In the classroom on a beautiful day			
Chairs not pushed in			
Being recess monitor			

THING	CAN HANDLE	CAN'T HANDLE	SECRETLY ENJOY
Hungover at work			
"There's a call for you."			
Other people's babies			
Pooping at school			
Desk organizing			
"Do you have five seconds to chat after class?"			
Crafting stores			
TikTok challenges			
The school song			
The school mascot			
Field trips			
Halloween			

Journal:

Mostly I need these things to not exist, thank u:

GET THROUGH THE FIELD TRIP WITHOUT LOSING YOUR MIND (OR A KID)

Avoid teenagers looking for somewhere to make out! Missing approval forms! Having to hand over your delicious, delicious sandwich to the kid who forgot to pack lunch!

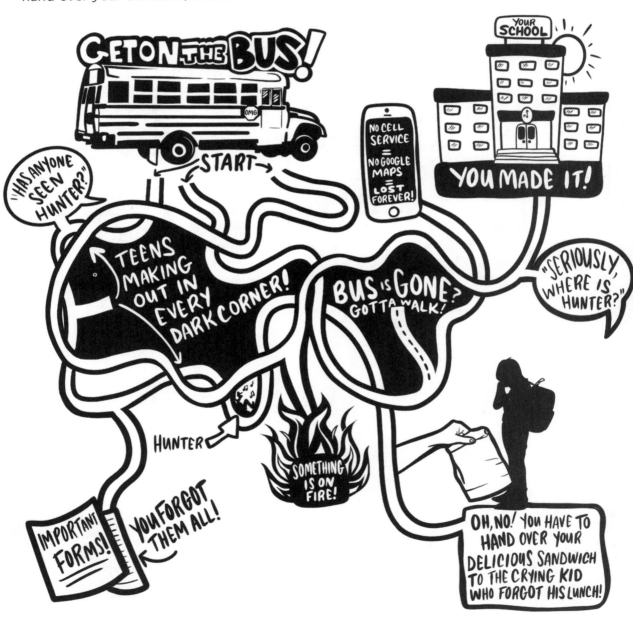

FRIDAY AFTERNOON BRAIN DUMP

What's a brain dump? It's like a dump, but for your brain (in a good way). There are two ways to do an Official Brain Dump™: 1) task-oriented, and 2) free-form. Both are an excellent way to kick off your weekend so you have extra mental space for the important things, like whether to get the cinnamon-raisin bagel or the blueberry.

Task-oriented: Write down all the things you have on your to-do list, no matter how tiny. Now all of those things have been freed from your brain, and you can go ahead and check them off (or come back to them later without worrying you'll forget about them). Also, it's a scientific fact that check marks = satisfaction.

Free-form: Just write down whatever pops into your head. Yes, *whatever.* It doesn't even have to make sense. Aaaaaaand go!

WORD SEARCH:
THINGS YOU NEED FEWER OF IN YOUR LIFE

Mostly, for your name not to be screamed at chainsaw-level volume while simultaneously being poked. Over. And over. And over.

Farts

Excuses

Opinions

Blatant lies

Repetition

Common Core adjustments

Sticky notes

Drama

Used staples

Copying

Texting

Humming

Tapping

Yelling

Whining

Noise in general

Sneeze dabs

```
X S U G P A Q N J H G X X A Y F Q N O G A C U W P S T I O S
H T G Z A R P C Z N K S I P S N N I J E O M D Z O E G I S R
J R G G Z B G H I O J Q R R O P Z M T M L J A E U L C M F G
C A E W T D G Y D Q V R G C G C C X M H C L T R Z P G G G K
M F L K Y J P H K E A K B S C N X O M L N O A U D A U A O S
Y Z H R M O W X P R W Q D R W W N I E S M O U A K T R R G D
D Z L M C E L U A Q V K N G P C U S B T N C L M N S R I G U
H S X A R R L A Y F N A N V O K S R D V J R H L Y D O K W M
C R G E A E J Z R M I J C R J T R K G C X Y Y W K E E U G H
E F S M L W D J M E A G E I B N C F K A C Z U U Z S T W C Z
I N T E X T I N G K N A E S N H T X F M D Y I G Q U J B S Y
Q H M K Q Z Z W N G D E F B V C Z T E K T B X Y N W N S B A
B G N I N I H W J J L F G J K Q F K L O L Z D G W C E L A I
D L Z B K F L J U T A F V N K E H J G J R H I O Q S X A D O
Z I A Z H S A S D A G W X D I T O I N F K Z T A U R R E E V
T F U T U M T J X P J O H E M E A X X B K J Y C X T J I Z B
R M R X A M Z A C P W K J U Y T S N I N X P X A W N N L E Q
T P E I E N H S D I N T B B M D T I D I E W P D E K Y E V
J W Q N N O T P Y N R C Z S Z M K Q O M K A U G Q H B I N W
R R T F U K H L O G K W Y J O O I A Z N R W J C W V I K S T
R S D X N Y F L I K V E X M R W S N A O D M R S C I I I M X
E W P J S L P Y O E L R D G Z Y M E G X B K W E D A W X G M
P W F R G R Q A O L S E R O Q B B I J U Q O P I N I O N S F
E Z P C C V Q O I T V F I H U T U O D Q Y T C Q V G A A I V
T N Y F M Q U N E I Z F V Y Y P W J D A T E G U B N R J Y Y
I V V V G P G V P E W B V H P H A B H X M F J H Q T J O S E
T I N W S D S E T O N Y K C I T S A G A T Q T K C Q B G O Z
I S I R P I I O P N H K L D Q J U E A E X N P H Q P O S Z Y
O F R T P R Z M R F W W B G L Q B O Q F P B H W W A C C X H
N Y T M P D T C P Y H B W H J D U X S T D R N F C Z K T H V
```

DRAW YOUR HAPPY PLACE (AND PUT YOURSELF IN IT)

MY MEMORIES, FOR POSTERITY

The first time I realized I wanted to be a teacher: _____

My first mentor: _____

My favorite thing about teacher college: _____

How I'd describe my first day as a teacher: _____

What I wore on my first day as a teacher: _____

My first teacher's pet: _____

The most important thing I learned during my first year: _____

The first three things I do when I arrive in my classroom: _____

My favorite thing about a rainy day: _____

My favorite thing to do when I get home from school: _____

When I close my eyes and think of lying in the grass, this is where I am: _____

The last thing I do before I fall asleep at night: _____

Even though I'm a jaded grown-up now, I still believe in: _____

SCAVENGER HUNT:
THE PLAYGROUND

☐ A sparkle in the pavement

☐ A leaf in the shape of a heart

☐ A flower in an unexpected place

☐ A coin

☐ A discarded wrapper
(Bonus: Throw it in the trash!)

☐ A branch that looks like a Hogwarts wand

☐ A cloud that looks like an animal

☐ Something that smells amazing

☐ A treasure, whatever that means to you

☐ A tree that would be fun to climb

☐ A bug that is kind of cute

☐ Something a kid clearly lost (Bonus: Bring it to the office!)

☐ Something that would probably smell terrible, if you got closer to it, which you won't

☐ A bug that is not cute in any way at all

OBSCURE TEACHER LAWS

Impress and horrify your friends at trivia night.

In West Virginia, children with "wild onion breath" must stay home from school. Store-bought onion breath, however, is A-OK.

Students in China are permitted to nap for thirty minutes every single day. Can teachers get this one, too? Please?

In Florida, school buses are explicitly forbidden from being used to ferry around cows and pigs and other livestock. Which begs the question: What if one has an emotional support sheep?

In Arkansas, people rocking bobs may not be given raises. Time to bring back The Rachel!

A 1915 rule in a Sacramento school forbade teachers from loitering in downtown ice cream shops. Give a gal a pint or two of rocky road, and *watch out*.

In Fresno, California, elementary schools cannot be used as venues for poker tournaments. Which . . . you know . . . sounds about right.

At a school in Nottinghamshire, children are not allowed to raise their hands. In other news, Nottinghamshire teachers are saving a *ton* of money on air freshener.

Related: A Pennsylvania school banned the use of Axe body spray. This makes perfect sense if you have ever smelled Axe body spray.

In 1872, teachers were allegedly required to spend part of their workday filling lamps and cleaning chimneys. Nowadays, of course, they are required to do everything else. (See Jobs You Don't Get Paid For Word Search on pages 44–45.)

HOW MANY WORDS CAN YOU MAKE OUT OF THE LETTERS IN "WILD ONION BREATH"?

DEATHBLOW

ORATION

FILL THE CLASS FISH TANK WITH FISH
(THAT YOU WON'T ACCIDENTALLY KILL)

. . . And give them fun names, of course.

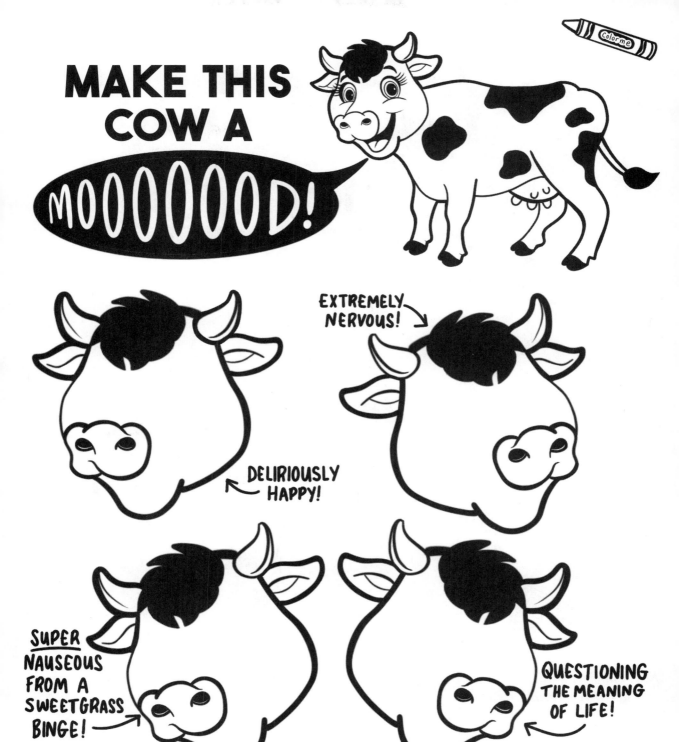

Changing only one letter at a time, make as many words as you can out of the above (extremely overused) phrase.

MENTAL HEALTH
CHECK-IN:

Today is __/__/__.

I'm feeling _____.

The worst part of my day was _____

_____.

The thing that I did to make myself feel better was _____.

Here is something I did today that I'm proud of: _____

_____.

For that, I deserve a _____.

I also did these things, which are great: _____

_____.

I made someone else's day better by _____

_____.

Now that I think about it, today wasn't so bad.

CREATE YOUR
MONDAY MORNING
PLAYLIST

Got a case of the Mondays? These tracks will help.
And none of them is "Eye of the Tiger." You're welcome.

"Wake Me Up"	Avicii
"Good As Hell"	Lizzo
"All I Do Is Win"	DJ Khaled
"High Hopes"	Panic! At The Disco
"Love Myself"	Hailee Steinfeld
"Confident"	Demi Lovato
"America's Sweetheart"	Elle King
"Girl on Fire"	Alicia Keys
"Shake It Off"	Taylor Swift
"Diamonds"	Rihanna
"I Like It"	Cardi B
"Express Yourself"	Charles Wright & the Watts 103rd St. Rhythm Band
"Up Around the Bend"	Creedence Clearwater Revival
"Build Me Up Buttercup"	The Foundations
"Ain't No Mountain High Enough"	Tammi Terrell & Marvin Gaye

My personal Wake-Up Anthem: _____.

THINGS BEING A TEACHER RUINED

The ability to say nothing when another adult human makes a grammatical error.

The ability to get through a day without being sticky.

The ability to get through winter without coming down with the plague.

Any and all previously held patience for lame excuses.

The concept of a footloose and fancy-free summer break.

Just yelling when you feel like it.

The smell of burritos.

Dry-clean-only clothing.

Your ego.

Journal:

Also, these things, sigh:

WOW, YOUR HEAD IS REALLY BIG.

MATCH THE QUOTE TO THE PERSON WHO QUOTH IT

1. EDUCATION IS NOT THE FILLING OF A POT, BUT THE LIGHTING OF A FIRE.

2. A teacher affects eternity; [They] can never tell where [their] influence stops.

3. TEACHING IS THE GREATEST ACT OF OPTIMISM.

4. I AM NOT A TEACHER, BUT AN AWAKENER.

5. I CANNOT TEACH ANYBODY ANYTHING I CAN ONLY MAKE THEM THINK.

6. THE MEDIOCRE TEACHER TELLS, THE GOOD TEACHER EXPLAINS, THE SUPERIOR TEACHER DEMONSTRATES, THE GREAT TEACHER INSPIRES.

7. GOOD TEACHING IS 1/4 PREPATION AND 3/4 THEATRE.

8. THERE IS NO FAILURE, ONLY FEEDBACK.

9. A GOOD TEACHER IS ONE WHO MAKES HIMSELF PROGRESSIVELY UNNECESSARY.

10. THE WAY WE TALK TO OUR CHILDREN BECOMES THEIR INNER VOICE.

11. KIDS DON'T REMEMBER WHAT YOU TEACH THEM, THEY REMEMBER WHAT YOU ARE.

12. JUST dance.

130

YOUR ANSWERS

A JIMHENSON ⟶ #

B W.B. Yeats ⟶ #

C ROBERT FROST ⟶ #

D Peggy O'Mara ⟶ #

E THOMAS CARRUTHERS ⟶ #

F William Arthur Ward ⟶ #

G SOCRATES ⟶ #

H Colleen Wilcot ⟶ #

I LADY GAGA ⟶ #

J HENRY B. ADAMS ⟶ #

K GAIL GODWIN ⟶ #

L ROBERT ALLEN ⟶ #

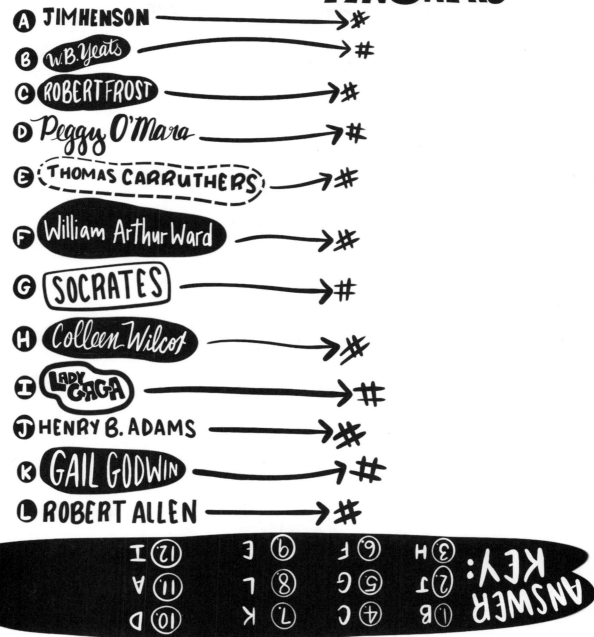

ANSWER KEY: ①B ②J ③H ④C ⑤G ⑥F ⑦K ⑧L ⑨E ⑩D ⑪A ⑫I

131

DRAW FOUR PEOPLE WHO ARE ALWAYS THERE FOR YOU

Even during the most stressful of times, we're sometimes surprised to find unexpected avenues of support. Maybe your brother or your former college professor has been there for you in moments when you were questioning your choices. Or maybe your Postmates delivery lady is your personal angel on earth.
Show those heroes some love.

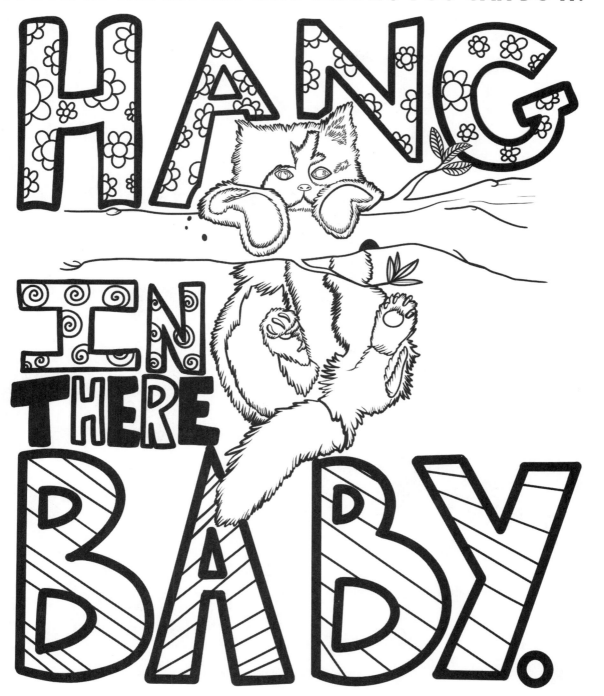

HANG IN THERE BABY.

133